BETTER PICTURE GUIDE TO
Photographing People

RotoVision

A RotoVision Book
Published and Distributed by RotoVision SA
Rue Du Bugnon 7
CH-1299 Crans-Près-Céligny
Switzerland

RotoVision SA, Sales & Production Office
Sheridan House, 112/116A Western Road
Hove, East Sussex BN3 1DD, UK.

Tel: +44 (0) 1273 72 72 68
Fax: +44 (0) 1273 72 72 69
e-mail: sales@RotoVision.com

Distributed to the trade in the United States by:
Watson-Guptill Publications
1515 Broadway
New York, NY 10036
USA

10 9 8 7 6 5 4 3 2 1

ISBN: 2-88046-393-9

Book design by Brenda Dermody
Diagrams by Roger O'Reilly

Production and separations in Singapore by ProVision Pte. Ltd.
Tel: +65 334 7720
Fax: +65 334 7721

BETTER PICTURE GUIDE TO

Photographing
People

MICHAEL BUSSELLE

Contents

Photographing People Outdoors

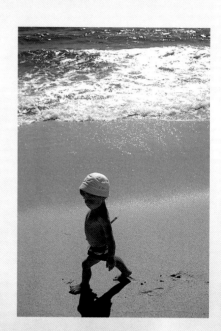

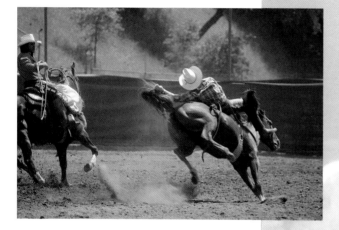

1

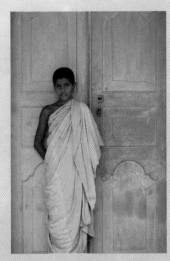

You need only to watch the output of any photolab's processing machine for a short while to realise that people are by far the most popular photographic subject, and that most of them will have been pictured outside. And yet it's fair to say that the vast majority of these images will be of little more than fleeting interest to anyone except perhaps the photographer and the subject involved. This chapter explains and illustrates the ways in which such images can be given a much wider and lasting appeal with only a small amount of extra effort.

Informal Portraits

Photographs of family and acquaintances are invariably among the first which a photographer will attempt. Pictures like these, taken in a relaxed and informal way, can result in a pleasing and characteristic likeness of a subject. If, however, you want to progress to produce images which are also satisfying photographs in their own right, you do need to cultivate an approach which is more careful and considered.

Seeing

I saw these two charming old ladies as I walked past their house in a village in Alsace, and could not resist the appeal of their relaxed attitude as they rested after sweeping the attractive old courtyard. The hazy morning sunlight I encountered had created a pleasantly atmospheric quality.

Thinking

Since I had already asked their permission for a photograph, my first thought was to approach them closely, shooting them as a straightforward double portrait. On reflection, however, I felt the most pleasing way of photographing them was to include more of the setting in which they were seated. Although sunlit, the light was soft and the shadow it cast was attractive, ensuring that the contrast between the shaded ladies and the highlight on the distant wall wasn't too great.

Acting

I decided to use a wide-angle lens so that I could move in close without the ladies appearing too large in the frame while, at the same time, I could include a reasonably large expanse of the building behind them. I framed the shot so that they occupied the bottom quarter of the frame and the edge of the shadow led away diagonally to the sunlit wall.

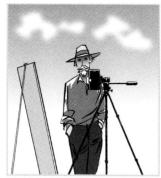

The shot of my friend, the painter Bruce Pennington, was taken on a cloudy day in his shaded garden and, since the soft daylight was hitting him from directly overhead and creating shadows on his face, I used a large white reflector as close as possible under his chin to bounce light back into this area. I used one of the paintings he was working on as a background which has echoed the overall bluish quality of the image.

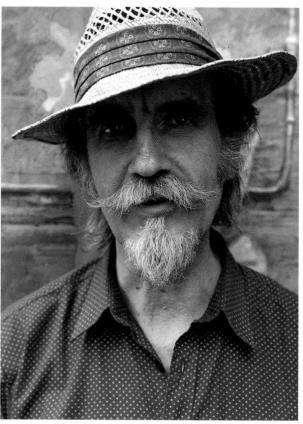

Technical Details ▼ 35mm SLR Camera with a 28–70mm zoom lens and Fuji Astia.

One way of ensuring a relaxed and natural-looking portrait is to ensure that your subject is comfortable. They need not necessarily be seated but they should be posed in a way which avoids the rigid, standing-to-attention appearance which often results when a photographer says, 'Let me take your picture', without first considering the models comfort.

Technical Details
▼ Medium Format SLR Camera with a 55–110mm zoom lens, an 81A warm-up filter and Fuji Velvia.

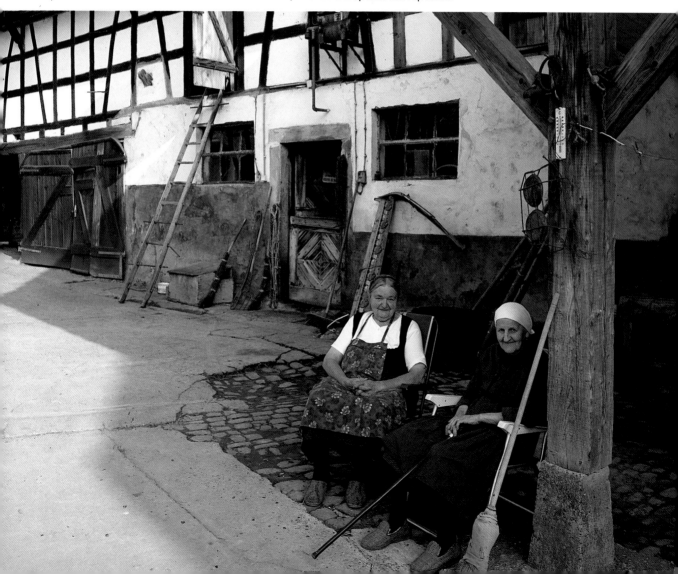

Informal Portraits

Be very wary of approaching your model too closely when shooting close-up head shots, as this can produce an effect where the subject's features are noticeably distorted with the nose and chin appearing disproportionately large. As a general rule, around one-and-a-half metres should be considered the safest minimum distance. If you wish to obtain an image which has a tighter crop, you can use a long-focus lens.

Seeing

Also taken in Sri Lanka, this portrait of a shop-keeper appealed to me because of the contrast between his rich brown skin and the colour of the screen he was standing behind. I also liked the shapes created by the windows.

Thinking

My first thought was to shoot this as a closer, upright image but this would have reduced the amount of blue and detracted from the overall effect I was after. I also felt that his slightly apprehensive expression would be less disconcerting if I shot the picture as a horizontal, allowing his face to feature less prominently in the image.

Acting

I composed the shot to include all of the screen and both of the adjacent windows, a view which filled the frame quite nicely and also placed him just off centre.

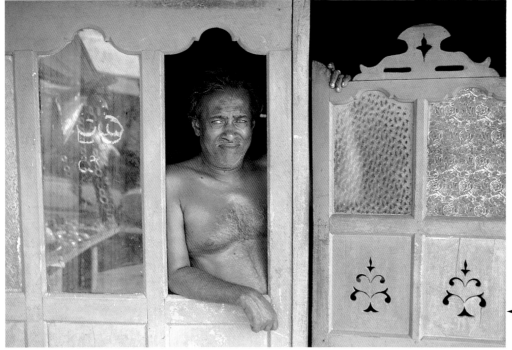

Technical Details
35mm SLR Camera with a 75–150mm zoom lens and Fuji Velvia.

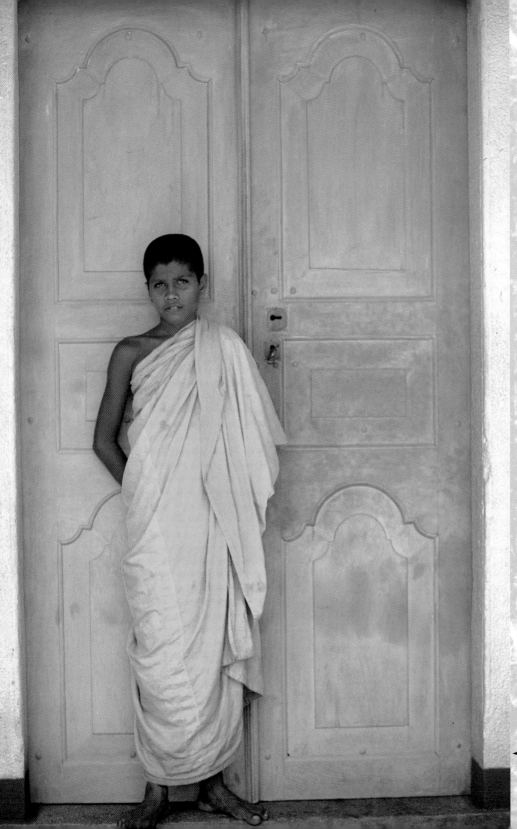

I asked this young Buddhist monk if he would stand in front of the beautiful blue door of this Sri Lankan monastery so that the colour contrast between this and the saffron of his robe would be quite startling. The picture was composed so that the door almost filled the viewfinder, acting as a frame within a frame, and I asked the monk if he would stand slightly to one side of the centre of the image to give it more balance.

Technical Details
35mm SLR Camera with a 70–150mm zoom lens and Fuji Velvia.

Informal Portraits

Seeing

I'd stumbled across this old village in Galicia, Spain, near the Portuguese border, and had spent some time shooting the old houses and almost mediaeval farm carts and implements which were scattered around. These two farmers were watching me with amusement, and I thought they would make great subjects for a double portrait in a setting which was almost too good to miss.

Thinking

I wanted to find a background which was not too obtrusive but which, at the same time, conveyed something of the remarkable old village's character and atmosphere.

Hazy afternoon sunlight from one side had created a pleasing degree of modelling on this French farmer's face, and I framed the shot to include most of the nice old wicker basket he was holding and some of the oak barrels on his cart.

Technical Details
▼ 35mm Medium Format Camera with a
105–210mm zoom lens and Fuji Velvia.

This was a very impromptu picture of a family harvesting their grapes, and I had little opportunity to arrange things carefully. The soft evening sunlight wasn't too harsh, however, and since its direction was just to one side of the camera, it created only small facial shadows. To get the photograph I wanted, I needed only to quickly position them so that each face could be clearly seen against the blue sky.

Technical Details
▼ 35mm Camera with a 35–70mm zoom lens and Fuji Velvia.

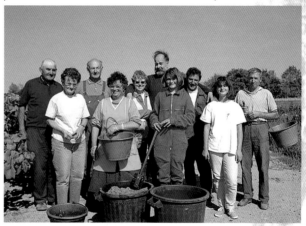

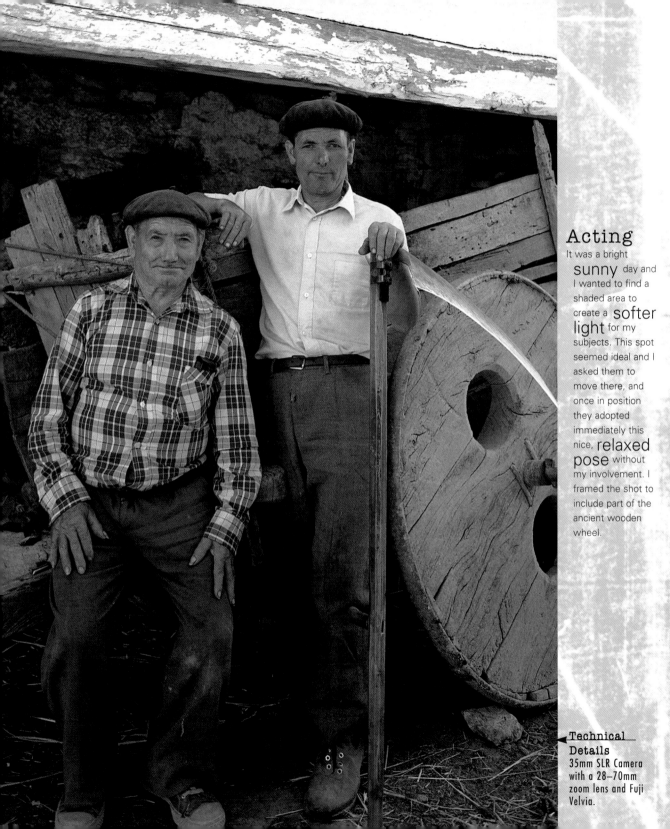

Acting

It was a bright **sunny** day and I wanted to find a shaded area to create a **softer light** for my subjects. This spot seemed ideal and I asked them to move there, and once in position they adopted immediately this nice, **relaxed pose** without my involvement. I framed the shot to include part of the ancient wooden wheel.

◄ **Technical Details**
35mm SLR Camera with a 28–70mm zoom lens and Fuji Velvia.

People at Work & Play

Taking photographs of people when they are occupied in some way has a number of advantages. Perhaps most importantly, it helps your subject to overcome the inhibited and self-conscious attitude which can often be adopted when a camera appears. Another major plus point to be gained from your subject actually doing something is that it will invariably add enormously to the interest and composition of an image, as well as help to reveal more about the person's character and interests.

Seeing

I saw this man tending his garden as I drove through a country lane near Ancenis in the Loire Valley, France. I was struck by the pleasing colour quality created by his blue work clothes and the rich green of his vegetable patch.

Thinking

He was working in a partially-shaded area and I noticed that this created both a pleasing light on his face and also made his blue overalls stand out quite boldly from the more brightly lit background.

I saw this lady making hay as I drove along a country lane near Santillana de Mar in Cantabria, and I liked the bold shapes the scene created. It was an overcast day and the lighting was soft, but the image has enough contrast because the darker tones of the lady and her mule and cart stand out against the light tones of the meadow.

◄ Technical Details

35mm Camera with a 75–300mm zoom lens, an 81B warm-up filter and Fuji Velvia.

Rule of Thumb

When any degree of subject movement is involved, it is necessary to use a shutter speed which is fast enough to freeze it. Even just normal hand movements can create a disturbing degree of blur if a slower shutter speed is used, and this will be accentuated when subjects are close to the camera. As a general rule, you should try to shoot at speeds of 1/125 sec or faster when photographing people.

I used a long-focus lens to obtain a good-sized image of this rodeo rider in California from a viewpoint some distance away, and used the fastest practical shutter speed to freeze the movement.

◄ Technical Details

35mm SLR Camera with a 300mm lens, an 81A warm-up filter and Kodak High Speed Ektachrome.

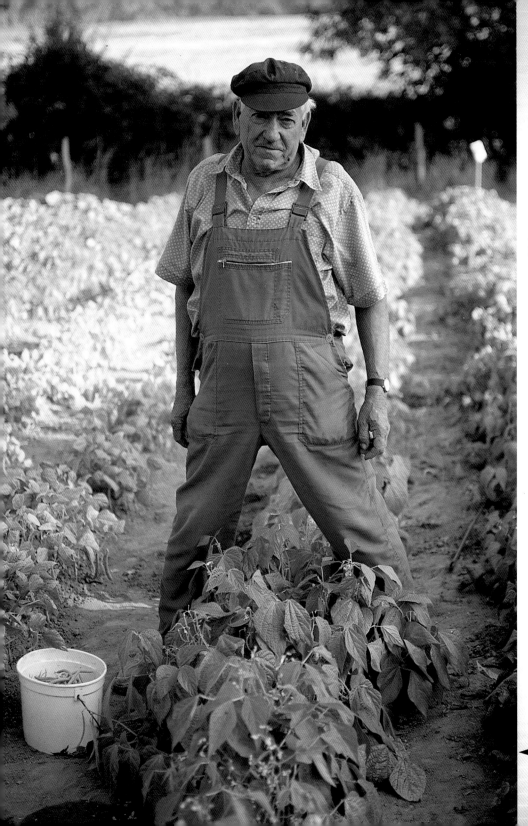

Acting

He was already standing in this position when I interrupted him and I thought it made a **interesting shape**. I chose a viewpoint which enabled me to shoot along the row of vegetables to make the most of his pose. Looking from my position, his head was set partly against the light tone of the distant meadow which has helped to give it more **prominence**.

◄ **Technical Details**
35mm SLR Camera with a 35–70mm zoom lens, an 81A warm-up filter and Fuji Velvia.

People at Work & Play

Seeing

I saw this man setting up his easel in the very early morning while I was shooting pictures in Brussel's Grand Place, a location I knew would, within a few hours, be teeming with tourists.

Thinking

I felt that he would not only make a very interesting subject for a picture, but would also add a very useful element of scale and composition to my pictures of the square.

Acting

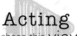

I chose this viewpoint as, although it was a back view of the man, it showed clearly what he was doing and conveyed something of his character as well as allowing me to use one of the square's medieval buildings as a background. I framed the shot in a way which placed his painting at the intersection of thirds, and this allowed me to include most of the building as well as his dog, which I thought added a nice touch.

Technique

When photographing people in action there are usually periods where their movements are slowed momentarily and, by choosing these times to make your exposures, you can usually obtain a sharp image even when using slower shutter speeds.

Technical Details

▼ 35mm SLR Camera with a 75–300mm zoom lens, an 81B warm-up filter and Fuji Provia.

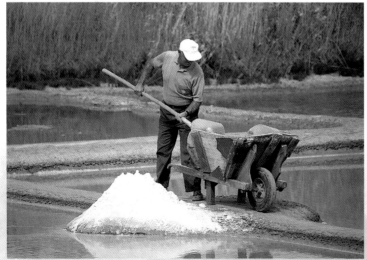

I found this man harvesting salt near Guerande in the Western Loire, and I looked for a viewpoint which would enable me to place an area of golden reeds behind him to create an effective background. I used a long-focus lens to frame the image so that the main focus of interest became the man with his pile of salt.

Technical Details
▼ 35mm SLR Camera with a 35–70mm zoom lens, an 81A warm-up filter and Fuji Provia.

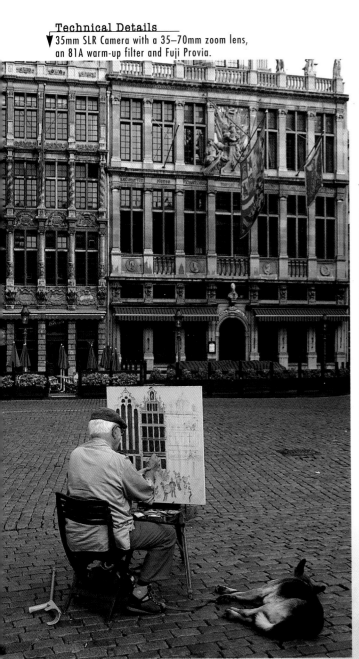

For me, the appeal of this shot, taken at a goose farm in Gascony, depends upon the overall colour quality created by the almost purple shade of blue to be found in the woman's dress and apron, the soft light and the grey, shadowed background of the geese and their pen. For this reason I decided to frame the image quite tightly to emphasise these qualities and placed the brightest part of the image, her straw hat, almost on the intersection of thirds.

Technical Details
▼ 35mm SLR Camera with a 35–70mm zoom lens, an 81A warm-up filter and Fuji Provia.

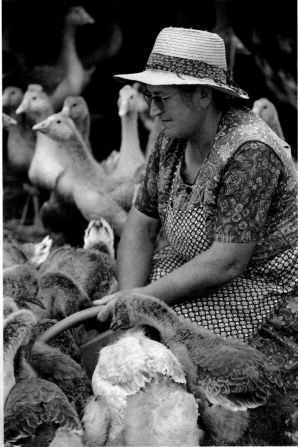

The Candid Camera

Once people see you with a camera, you run the risk of them becoming stilted and self-conscious, but you can avoid this problem, and produce pictures which are completely spontaneous, by taking pictures of people when they are unaware of you. You do need to take some care, however, since such pictures can easily become muddled and confusing if you do not give enough thought to the composition of the image and the choice of viewpoint and background.

Seeing

I was wandering around the weekly market in Colmar, France, when I saw this farmer waiting in his car at the edge of the square. The incongruous juxtapostion of the eggs on the car roof with his head below, framed by the window, appealed to me enormously.

Technical Details
▼ 35mm Rangefinder Camera with a 45mm lens, an 81B warm-up filter and Kodak Ektachrome SW.

Thinking

I felt the greatest impact would be created by framing the image quite tightly and, as the man looked fairly settled, I had time to change to a long-focus lens and choose a viewpoint which showed his profile and placed the car in front of an unobtrusive area of background.

Acting

I framed the shot so that the eggs were almost at the top of the frame, while just enough of the car door was included to complete the frame effect, while excluding some distracting background details behind the car's windscreen.

Rule of Thumb

In situations like these, when you want people to be to be unaware that they are being photographed, it's best to keep a low profile as far as equipment is concerned. Don't carry a large and ostentatious camera bag or have your camera boldly displayed around your neck. I like to carry my camera partly hidden in my hand by my side, with a spare lens or two and some extra film in my pockets.

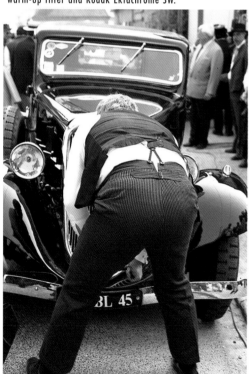

This was one of those fleeting opportunities, at a village festival in the Loire, when I found myself with very little time to change lenses or make decisions. My camera was fitted with a standard lens at the time so, when the man bent over to crank his car, I simply moved very quickly into a position where he and his vehicle filled the frame and shot almost immediately.

This diagram shows how the impact of this shot would have been lessened if the image had been less tightly framed.

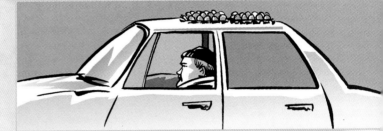

Technical Details
▼ 35mm SLR Camera with a 70–210mm zoom lens, an 81A warm-up filter and Kodak Ektachrome 64.

The Candid Camera

Seeing

I spotted this man in a street market in Bali, and was attracted by his **stance** and by the **limited colour range** featured in the scene.

Thinking

I wanted to shoot him while he was **unaware** of the camera but he had been **watching** me approach. Without looking too much in his direction, I moved to a good **viewpoint** just in front of him and then began **aiming my camera** at someone on the other side of the street.

Acting

He soon lost interest in me and began a **conversation** with his neighbour. At this moment I **quickly swung** the camera around, **framing** the image so that he was more or less in the centre where he was framed by the blue-green door and barrel.

Technical Details
35mm SLR Camera with a 35–70mm zoom lens, an 81A warm-up filter and Fuji Provia.

I spotted this shopkeeper, framed in his doorway in the souk of
Marrakech, and was attracted by the brightly coloured pile of oranges
beside him and the way the shaft of sunlight illuminated his profile,
creating a strong diagonal line. I framed the shot quite tightly so that
these elements were accentuated, and at the same time I was able to
exclude some distracting details on the left of the scene.

Technical Details
▼ 35mm SLR Camera with a 80–200mm zoom lens, an 81A warm-up
filter and Kodak Ektachrome 100 SW.

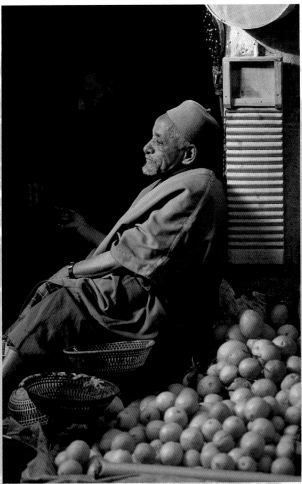

I was interested in the way this young lady, seen in a street
market in Bali, was preparing the food wrapped in palm
leaves. Although she was aware of my presence she was too
engrossed in her work to take too much notice, and this
allowed me to shoot a few frames without attracting her
attention.

Technical Details
▼ 35mm SLR Camera with a 35–70mm zoom lens, an 81A
warm-up filter and Fuji Provia.

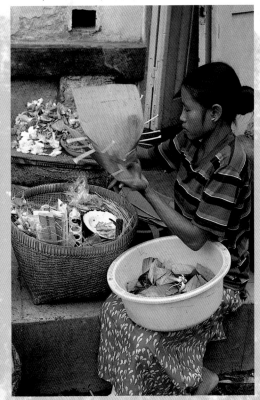

Shooting a Picture Story

Most photographs are taken as individual images, intended to stand alone and make a single statement. But it can be very satisfying to set out to take a series of photographs of a particular subject, or on a specific theme, in which each individual image is part of an overall story, almost like the tiles in a mosaic. In this way it is possible to adopt a more abstract approach and to focus on small details which, on their own perhaps, would not be very informative.

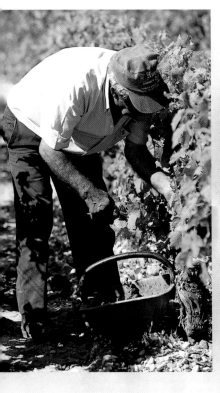

These pictures were taken in Pauillac in the Medoc, during the harvest in what is one of the world's most prestigious vineyards. I wanted to try to capture the mood of the occasion and the feeling of camaraderie which exists among the pickers, together with the sense of purpose which dominates the process.

◄ Technical Details ►
35mm SLR Camera with lenses ranging from 17mm to 200mm and Kodak Ektachrome 100 SW.

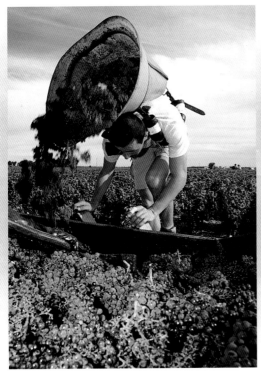

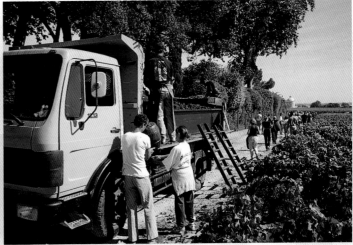

In the lesser wine regions grape harvesting is a largely mechanical process but here, where the truly great red wines are made, it's very much a hands-on business, a personalised activity where everyone involved has a sense of pride in the product.

Holiday Photographs

More pictures tend to be taken when families are on holiday than on any other occasion. But these are often extremely disappointing and uninteresting, of passing interest only to those who were there, and often very boring to those who weren't. The reason is simple. For most people holidays mean rest and relaxation, but if you want to take a good set of pictures it does require a little effort. It's time well spent, however, if at the end of the day you produce a set of pictures which provide a lasting and genuinely interesting record of a happy occasion.

Seeing

I saw this opportunity while shooting pictures on a cruise ship in the Caribbean. They were strangers, but even if they'd been my own family, it's the type of shot which I would always find more interesting and atmospheric than a picture of them sitting up and grinning at the camera.

Thinking

I liked the shapes and patterns created by the prone bodies which seemed to capture the mood of sunbathing and relaxation. I also liked the single splash of magenta which created a bold point of interest in the otherwise bluish scene.

Acting

I took up a viewpoint some distance away and shot with a longer lens to compress the perspective. By framing tightly to make the picture very compact, I was able to emphasise the colours of the tanned bodies and the swimming costumes.

Technical Details

▼ 35mm SLR Camera with a 75–300mm zoom lens, an 81A warm-up filter and Fuji Velvia.

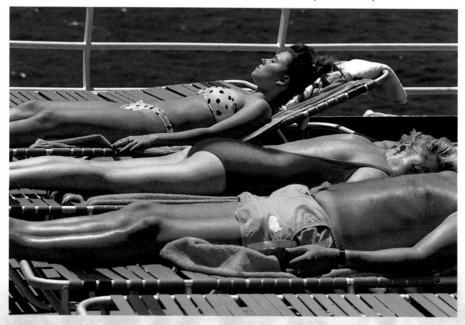

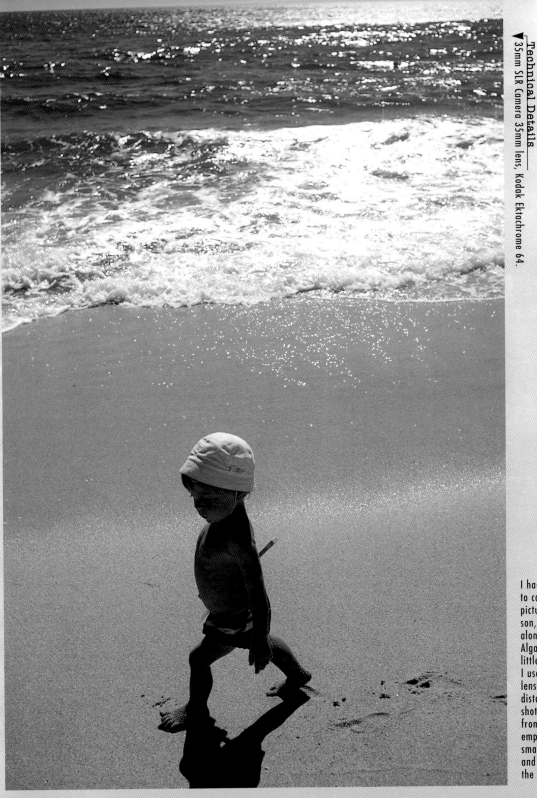

Technical Details
35mm SLR Camera 35mm lens, Kodak Ektachrome 64.

I had to react quickly to capture this picture of my young son, Julien, striding along a beach in the Algarve wearing his little white sunhat. I used a wide-angle lens to include the distant sea, and I shot looking down from eye level to emphasise the smallness of the child and the vastness of the beach.

Holiday Photographs

Seeing

The River Gambia was the setting for this shot, and I wanted to take a portrait of the skipper of the small yacht I was travelling on. The calm, still water made a good setting, and the late afternoon sunlight had a very pleasing quality.

Thinking

I wanted the background to be as uncluttered as possible, so I asked him to sit in the prow of the boat so that I could make the most of the river bank, the water and the sky.

Acting

I used a wide-angle lens since my choice of viewpoint was quite restricted and I did not want my subject to appear too large in the frame. I also wanted to include as much of his setting as I could.

Technique

Many holiday photographs are disappointing because there is often an attempt to combine recognisable portraits of people with pictures of a scene, the classic snap of someone standing awkwardly in front of a famous landmark. These are usually neither fish nor fowl, and it's generally far better to concentrate on one element or the other.

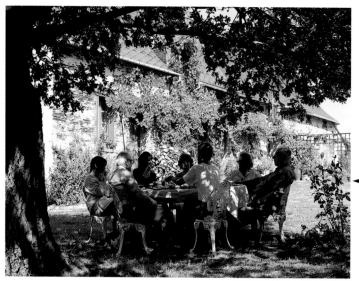

This picture was taken at a farmhouse in the Loire, and was an attempt to capture the atmosphere of a very relaxed alfresco lunch in the shade of a nice old tree on a beautiful hot, sunny day. I took a reading from the lighter tones of the background, then one from the shaded figures, and set my exposure between them.

Technical Details
Medium Format SLR Camera with a 55–110mm zoom lens with an 81B warm-up filter and Fuji Provia.

Technical Details ➤
35mm SLR Camera with a 20–35mm zoom lens with 81B warm-up and polarising filters and Fuji Velvia.

This shot was taken during a safari holiday in the Masai Mara, Kenya, and I wanted to try and capture the atmosphere and experience of staying in this camp under these magnificent Acacia trees. For this reason I used a wide-angle lens and took up a viewpoint some distance away in order to make the setting the dominant element, with my companions there mainly to provide a sense of scale.

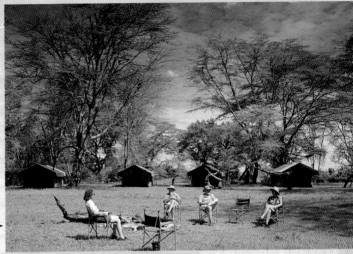

Technical Details ▶

35mm SLR Camera with a 20–35mm zoom lens with 81C warm-up and polarising filters and Fuji Velvia.

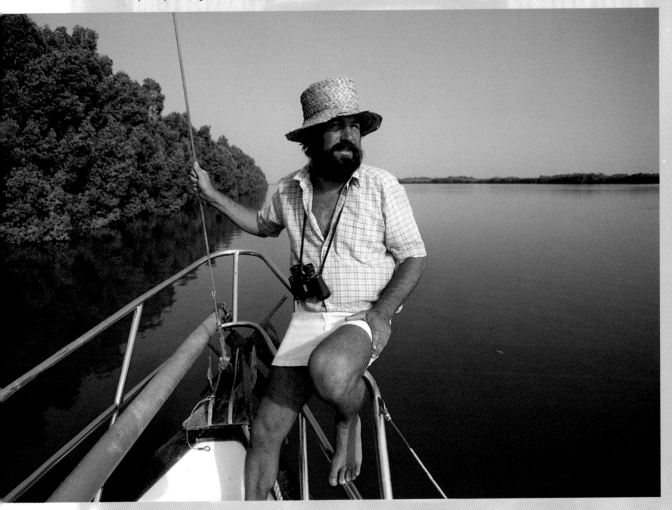

Photographing Children

There's an old saying among actors which maintains you should never work with children or animals. This is simply because they can so easily steal the scene. Children especially make wonderful subjects for the camera, and the very young invariably have the same sort of heart-melting appeal you generally associate with kittens and puppies. Unlike most adults, there's the bonus that children are still likely to be uninhibited and spontaneous, but photographing them does require time and patience.

Seeing

I saw this young boy playing with his pet duckling in the doorway of his home as I drove through a small **village in Andalucia,** and felt that I had to see if I could photograph him.

Thinking

I thought that my best approach was to ask his mother if I could take **a portrait** of him, rather than attempt a more **casual** and spontaneous picture.

Acting

Once I had the go-ahead I asked the boy to move **into the shade**, and I positioned him so there was an area of **plain wall** behind to provide an uncluttered **background**. As he held the duckling out in front of him, I was able to take a **tightly-framed** shot.

Rule of Thumb

When photographing children it's generally best to keep the image quite simple. Use soft lighting, plain uncluttered backgrounds and tightly-framed images to emphasise their expressions.

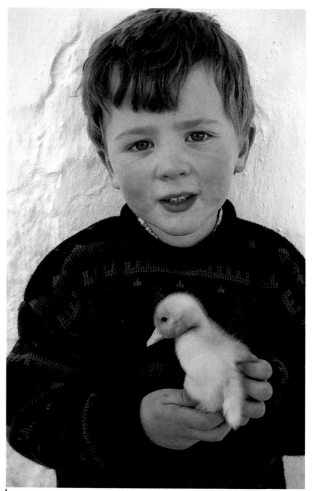

Technical Details

35mm SLR Camera with a 35–70mm zoom lens with an 81A warm-up filter and Fuji Provia.

I photographed this little Moroccan girl in the shade of a wall which also provided a good background. She was very shy but I managed to take a few pictures while she was distracted by one of my companions.

Technical Details
▼ 35mm SLR Camera with a 80–200mm zoom lens with Kodak Ektachrome 100 SW.

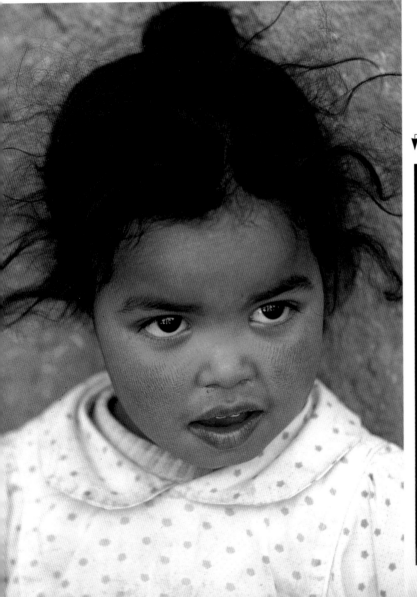

This little baby, seen in a village in the Gambia, was irresistible, sitting on her mother's lap in the shade of a small, mud-walled house. The soft lighting was ideal, and I framed the image tightly to emphasise her expression and to exclude distracting details around her. I set my exposure at one stop less than the reading to compensate for her dark skin.

Technical Details
▼ 35mm SLR Camera with a 75–300mm zoom lens and an 81A warm-up with Fuji Velvia.

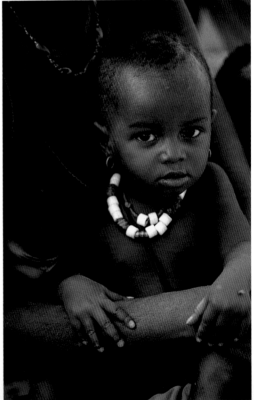

Photographing Children

Rule of Thumb

When photographing small children it's often best to come down to their level. The normal eye-level viewpoint of an adult often creates an unattractive perspective, while it's also more difficult to show children's faces and expressions from a high viewpoint.

This spontaneous shot was taken during playtime at a primary school. I used a long-focus lens to enable me to isolate one or two children from the crowd without me having to approach too closely to them, and then I set a fast shutter speed to ensure that all their movement was frozen.

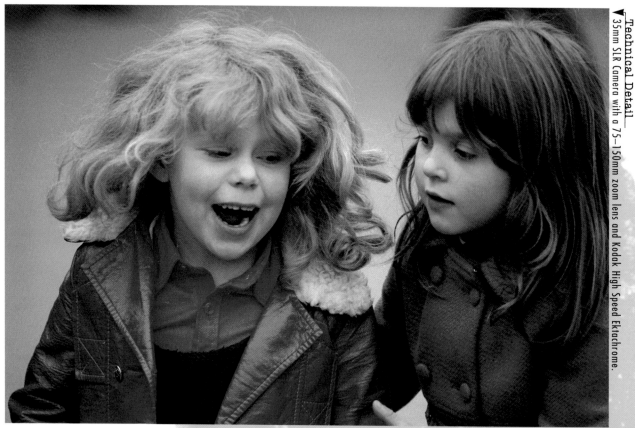

Technical Detail
35mm SLR Camera with a 75–150mm zoom lens and Kodak High Speed Ektachrome.

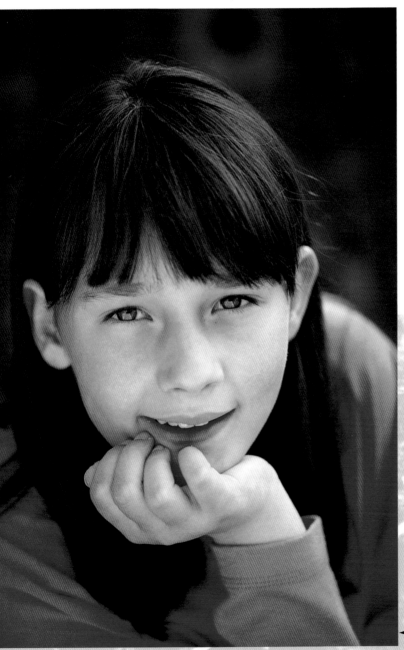

Seeing

I took this portrait in my garden on a sunny day. The light was quite harsh and the background of sunlit foliage was very distracting.

Thinking

I thought that my best approach would be to shoot into the light and to use a reflector and an artificial background in order to create a more pleasing quality.

Acting

I asked my young model to sit with her back to the light and then draped a piece of curtain fabric some distance behind her. I then placed a large piece of white polystyrene as close as possible to her to bounce light back into the shadows.

This diagram shows the lighting set-up for this shot.

6ft

Technical Detail
35mm SLR Camera, 75–300mm zoom lens and Fuji Provia.

Events & Occasions

Some of the most enjoyable situations to photograph people in are events such as fairs, festivals and family occasions such as parties and weddings. Pictures taken in these circumstances invariably have a sense of fun and good humour, and it's generally much easier to take shots where your subjects are completely relaxed and the atmosphere is lending itself to the taking of spontaneous and unposed photographs.

Technical Details
▼ 35mm SLR Camera with a 20–35mm zoom lens and a 81A warm-up filter with Kodak High Speed Ektachrome.

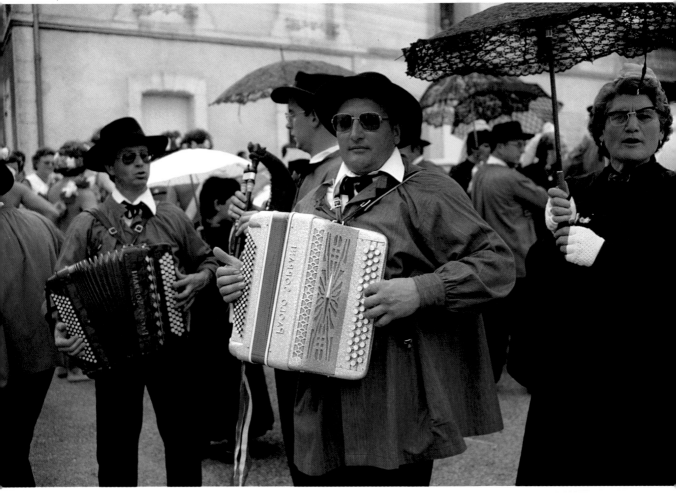

In some cases, the crowd at an event can provide a more interesting and photogenic subject than the activities taking place. Visiting the races in Nairobi, I was attracted by the wonderful mix of faces and fashions to be found there, and I used a long-focus lens to concentrate on the most interesting section of the crowd.

Technical Details ▶
35mm SLR Camera with a 70–210mm zoom lens and an 81B warm-up filter and Fuji Provia.

Rule of Thumb

Finding a good viewpoint is one of the most important things to concentrate on when shooting at public events and, for this reason, it's a good idea to arrive early. That way you give yourself the opportunity to pick a good spot, one which seems likely to work in terms of lighting and background, and which will offer you a good view of the activities.

Seeing

This folk group was performing at a small village wine fair in the Dordogne, France and I felt that with the right viewpoint they would make an interesting picture.

Thinking

Because it was a small, informal occasion I was able to get quite close to them and this seemed to be the best way of separating them from the bystanders and creating a more interesting composition.

Acting

I decided to use a wide-angle lens as this allowed me to get quite close to my subjects, while still including a reasonably large part of the scene around them. I framed this shot so that the lady with the umbrella on the right and the blue costume worn by the figure on the far left helped to enclose the central accordion player.

At a village festival in the Loire, I was attracted by the triangular shape created by the lady in her period costume. To photograph her I chose a viewpoint which placed her against a relatively plain area of background, framing the image quite tightly using a long-focus lens.

Technical Details

35mm Rangefinder Camera with a 90mm lens, an 81B warm-up filter and Kodak Ektachrome 100 SW.

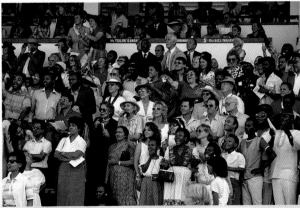

Events & Occasions

This shows how a slightly different viewpoint would have lessened the emphasis on the subject's face.

The viewpoint I chose for this shot, taken at a village wedding in Sri Lanka, placed this lady's face against the more distant white drum so that she stood out clearly. I used a long-focus lens to frame the image quite tightly and to exclude distracting details around her.

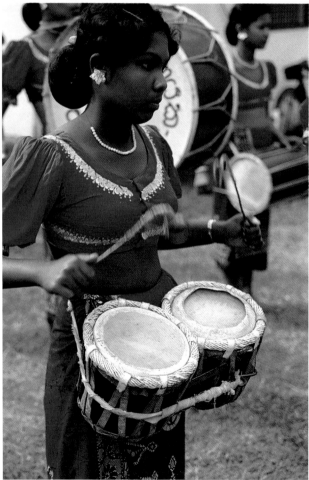

Seeing

The Changing of the Guard is a very popular and colourful event in London's Whitehall and must be one of the most photographed events in the world.

Thinking

I wanted to find a way to produce an image which was a little different from those I had seen many times before. I walked around the scene looking for a viewpoint which would give me a chance to do this and found that this back view of the guardsmen also offered me an effective background in the form of the distant building's facade.

Acting

I used a long-focus lens to isolate this small group of guardsmen and used quite a wide aperture to ensure that the distant building was unsharp enough to allow the main subject to stand out clearly.

Technical Details ▶
35mm SLR Camera with a 75–300mm zoom lens, an 81B warm-up filter and Fuji Provia.

◀Technical Details
35mm SLR Camera with a 75–150mm zoom lens, an 81A warm-up filter and Kodak Ektachrome 64.

Technical Details

▼ 35mm SLR Camera with a 35–70mm zoom lens, an 81B warm-up filter and Kodak Ektachrome 64.

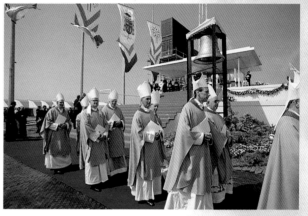

On a big occasion, such as the Pope's visit to Britain, the viewpoint is often the decisive factor in deciding whether you get successful photographs. In this case I was lucky enough to find myself close to the parading dignitaries, a position which allowed me to use a shorter focal-length lens to create a pleasing perspective.

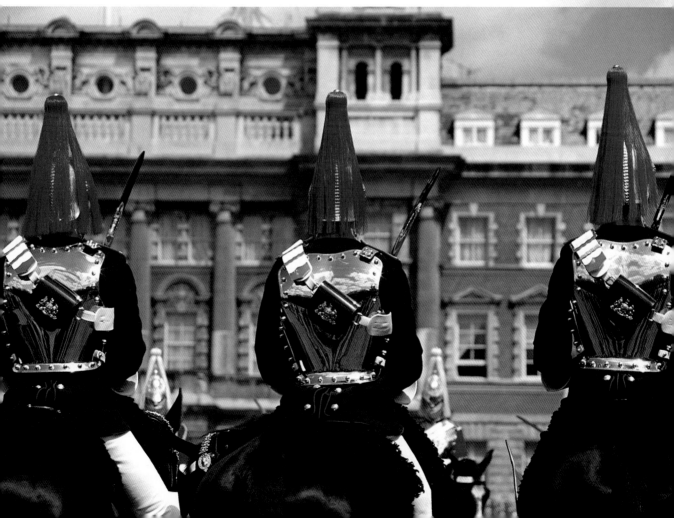

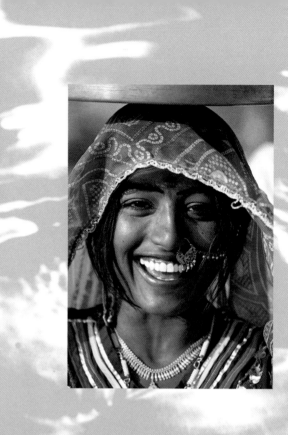

Composition & Light

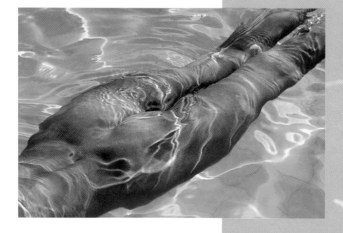

2

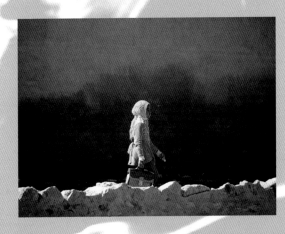

All photographs depend upon two
pivotal elements for their success, the
way in which the image is composed and the quality and direction of the light. Whether the
subject is a landscape, a building, a close-up or a portrait, if the image is not well organised
within the frame and the lighting does not reveal the inherently photogenic qualities of a
subject, the result will be, at best, a snapshot.

Using the Background

The background is a very important element in portrait photography, even when it occupies only a small area of the image. Many potentially good photographs turn out to be disappointing, simply because the same amount of thought and consideration has not been given to the background as there was to the subject.

Seeing

I passed this small shop while exploring the village of Lourmarin in Provence, and was attracted to both the shop front itself and the two lady proprietors who were watching the passers-by.

Thinking

I felt that both subject and background were of equal importance if the picture was to be a success, and because the two ladies stood out well from the darkened doorway I could afford to let them be quite small in the frame.

Acting

I decided to shoot from the opposite side of the street using a wide-angle lens which allowed me to include most of the shop front. I framed the image so the two ladies were more or less in the centre of the picture.

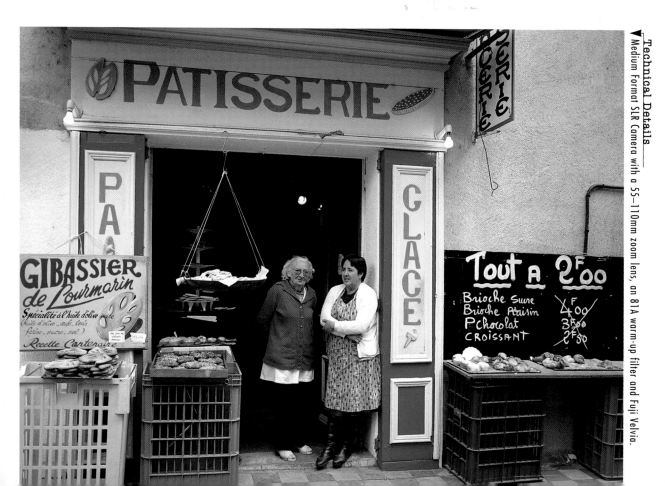

Technical Details
Medium Format SLR Camera with a 55-110mm zoom lens, an 81A warm-up filter and Fuji Velvia.

It was largely the background that inspired this shot, which was taken in the Souk in Marrakech, Morocco. I liked the colour and texture it offered, and was attracted by the way the colours in the man's robe were complemented. Had he been seated anywhere else I would probably not have photographed him.

Technical Details
▼ 35mm SLR Camera with an 80–200mm zoom lens, an 81A warm-up filter and Kodak Ektachrome 100 SW.

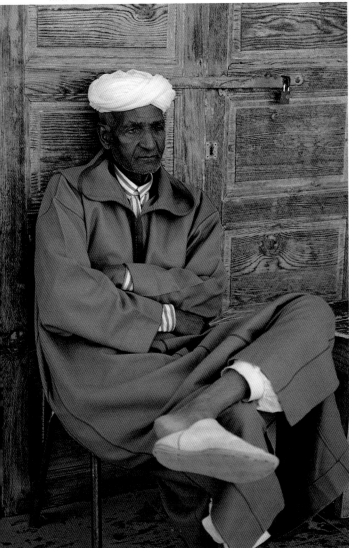

I used a low camera angle for this portrait of a Moroccan man, partly to create a slightly unusual perspective but also to enable me to use the sky as a background. From eye level, the viewpoint included some distracting details in the background.

Technical Details
▼ 35mm SLR Camera with an 80–200mm zoom lens, an 81A warm-up filter and Fuji Velvia.

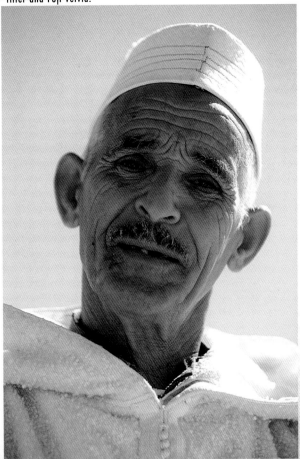

Using the Background

Seeing

While looking for a setting in which to place my model for this nude shot, I saw this strikingly-textured rock with its rich ochre colour and thought that it might echo the colour of the subject's tanned skin.

Thinking

With my model in position it was clear that the two colours did indeed work well together, while the limited colour range of the image further served to heighten the textural effect of skin and rock, while emphasising the difference between them.

Acting

I used a long-focus lens to frame the image quite tightly, while a polarising filter subdued some of the highlights on her body and increased the colour saturation.

Technical Details
Medium Format SLR Camera with a 150mm lens, a polarising and 81A warm-up filter with Kodak Ektachrome 64.

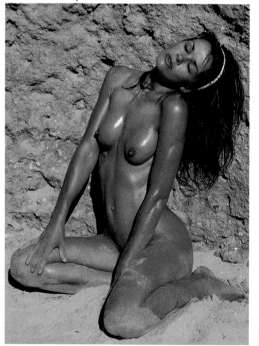

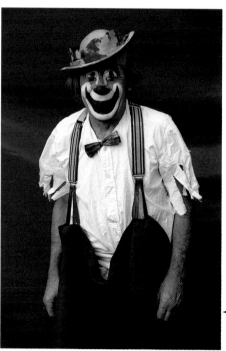

I photographed this clown outside the tent of a small travelling circus, using the big top itself as part of the background. I felt the contrast of the clown's white shirt and blue trousers seen against the tent's red canvas would produce a degree of impact.

Technical Details
35mm SLR Camera with an 75–150mm zoom lens and Kodak Ektachrome 64.

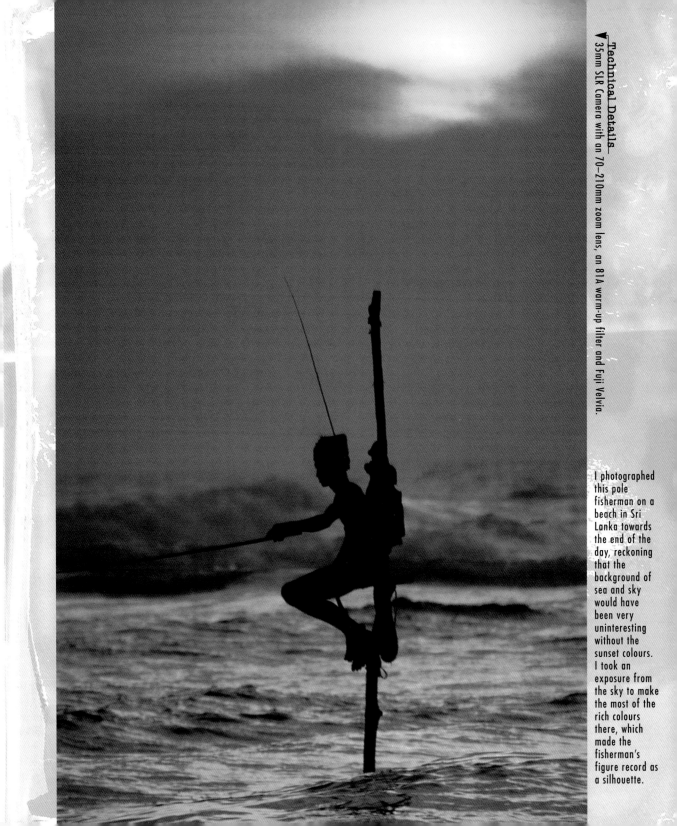

Technical Details
35mm SLR Camera with an 70–210mm zoom lens, an 81A warm-up filter and Fuji Velvia.

I photographed this pole fisherman on a beach in Sri Lanka towards the end of the day, reckoning that the background of sea and sky would have been very uninteresting without the sunset colours. I took an exposure from the sky to make the most of the rich colours there, which made the fisherman's figure record as a silhouette.

Framing the Image

Composing carefully through the camera's viewfinder is crucial to the success of the image. You should try to ensure that only the most essential details are included, and that the most important features of the image are placed within the frame in a way which gives them dominance while allowing you to create a balanced and harmonious composition.

Seeing

I saw this picture from my hotel bedroom window while staying in Negombo, Sri Lanka. I was attracted by the **bold shape** of the catamaran's sail as well as by the man's pose.

Thinking

I had to act quickly, and decided that it would be best not to attempt to include the whole of the boat as this would have meant some **distracting details** would be featured and that the man would be too small in the frame.

Acting

I decided to use a **long-focus lens** to frame the image quite tightly, and this also allowed me to place the man on the **intersection of thirds**.

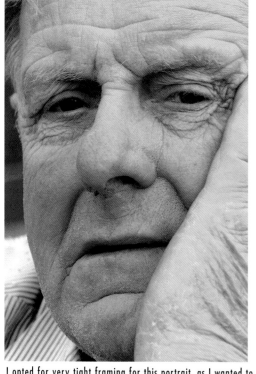

I decided a frontal viewpoint of this cottage, which I'd come across in a village in Normandy, was my best option, as I wanted to emphasise the patterned effect of the timbered facade and the shuttered windows. I framed the shot using my zoom lens to include the man's feet and all of the upper floor windows, and a viewpoint which allowed him to be in the centre of the image.

Technical Details
▼ Medium Format SLR Camera with an 55–110mm zoom lens, an 81A warm-up filter and Fuji Velvia.

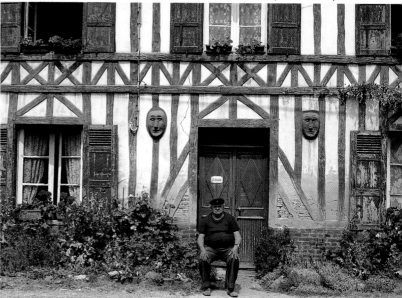

I opted for very tight framing for this portrait, as I wanted to emphasise the man's rich skin texture and to include as little background as possible. I used a long-focus lens and shot from around two metres away to avoid distorted perspective.

▲Technical Details
35mm SLR Camera with an 70–210mm zoom lens, an 81A warm-up filter and Kodak Ektachrome 64.

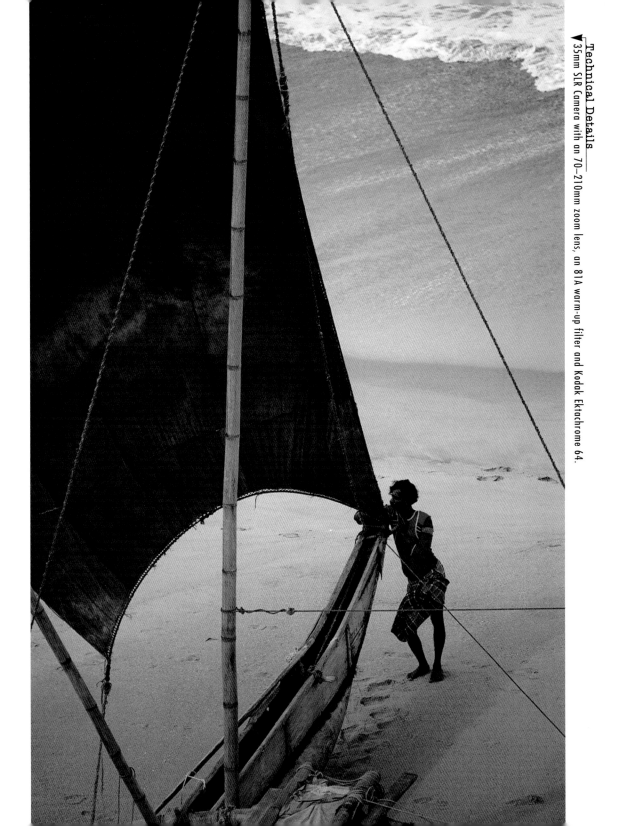

Technical Details ▼

35mm SLR Camera with an 70–210mm zoom lens, an 81A warm-up filter and Kodak Ektachrome 64.

Framing the Image

Rule of Thumb

One of the most common causes of photographs which lack impact is that too much information has been included in the image. Before making your exposure it is wise to first consider whether you could frame the image more tightly, by moving closer to your subject or by using a longer focus lens.

Technical Details

▼ 35mm SLR Camera with an 35–70mm zoom lens, an 81A warm-up filter and Kodak Ektachrome 64.

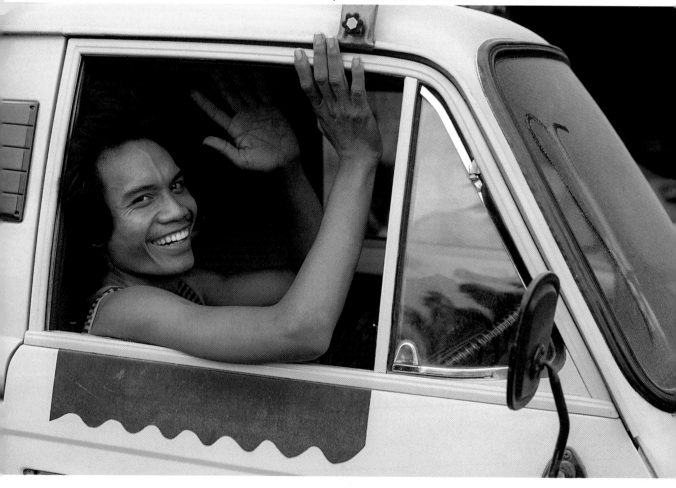

I would have photographed this situation, seen in a Moroccan village, even if the man and child had not been there. I framed my picture so that the background was quite symmetrical, and I placed my subjects in the centre of the composition.

Technical Details
35mm SLR Camera with an 70–210mm zoom lens, an 81A warm-up filter and Kodak Ektachrome 64.

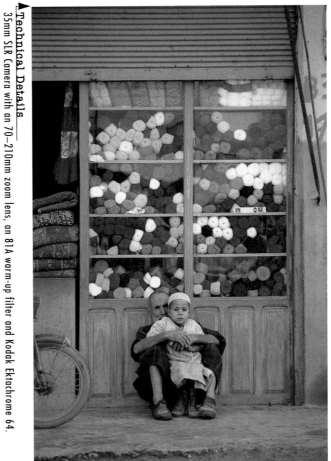

Seeing

I spotted this man in his van in a street in Bali, and was struck by the interesting combination provided by the rich brown of his skin and the bright saturated yellow of his van.

Thinking

I realised that the van's window could make an effective frame within a frame, and my first thought was to shoot from the side and square-on to the window, but this would have denied me an effective view of his face.

Acting

Instead I used a viewpoint from where I had a better view of my subject, and I framed the shot so that enough yellow was featured to be effective while the man himself was allowed to remain the dominant element of the image.

I framed this shot, taken during the Pope's visit to Britain, in a way which showed just enough of the umbrella to establish it in the picture, but decided against including more of it because it would have added detail which would have detracted from the picture and lessened its impact.

Technical Details
35mm SLR Camera with an 75–150mm zoom lens, an 81A warm-up filter and Kodak Ektachrome 64.

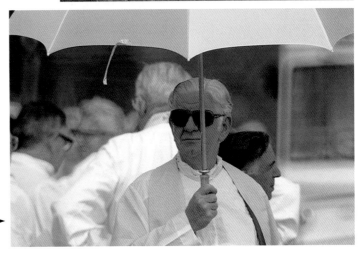

Shooting in Sunlight

Sunny days are the ones which are the most likely to inspire people to take photographs, and sunlight does indeed create lively images with a pleasing sparkling quality. But some care is required in such conditions, especially if you're planning to shoot pictures of people, since the harsh quality of direct sunlight and the high contrast it creates can easily produce unpleasant and unflattering results.

Seeing

This Spanish farmer was unsaddling his mule as I drove past his home, and I was struck by the bold shapes created by the pair of them when seen against the brightly-lit whitewashed wall. It was so perfect it almost looked like a studio set-up.

Thinking

It was afternoon and the sunlight, although harsh and strong, had mellowed slightly, and it was angled almost directly at them, creating only small shadows which had been weakened by the very reflective surroundings.

Acting

I chose a viewpoint which placed the man's head between the strings of brightly-coloured red peppers and the window grill, and I framed the shot to include the latter together with the mule's tail.

Rule of Thumb

It's best to avoid direct sunlight for head and shoulder shots, especially for light-skinned people. As a general rule on a sunny day it is preferable to place your subject in an area of open shade, such as beside a wall or under a tree, or to shoot your pictures with the light coming from behind them.

Technical Details ►
35mm SLR Camera with an 35–70mm zoom lens, an 81A warm-up filter and Fuji Velvia.

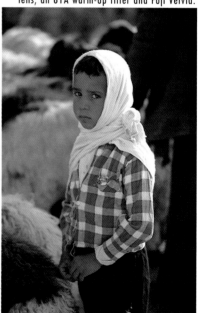

I shot towards the light for this portrait of a young Arab boy, spotted in a market in Israel, in order to avoid the harsh effect of direct sunlight. This also had the effect of creating a distinct separation between the subject and his background.

Technical Details ►
35mm SLR Camera with an 75–150mm zoom lens, an 81A warm-up filter and Kodak Ektachrome 64.

Technical Details
▼ 35mm SLR Camera with a 28–70mm zoom lens and Fuji Velvia.

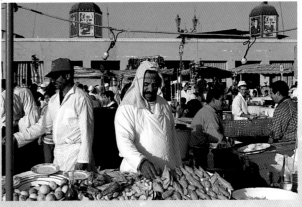

This shot was taken in the square of Jemma el Fna in Marrakech very late one afternoon, when the sun was at a low angle and its harshness had softened. I chose a viewpoint from where the shadows cast by the sunlight were relatively small and unobtrusive.

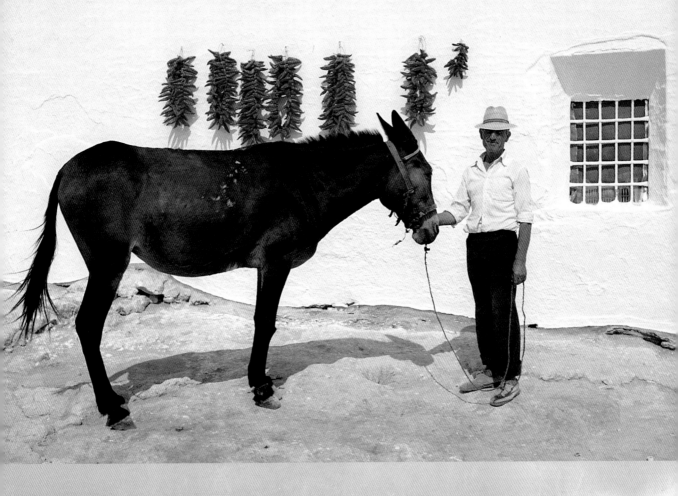

Shooting in Sunlight

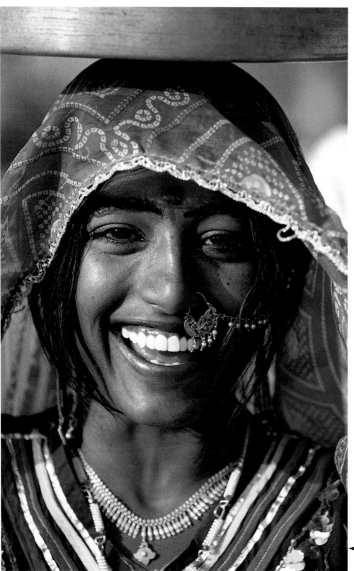

Seeing

Getting covered in sand was not intentional, and something normally to be avoided on a beach, but I liked the very tactile quality it created on the model's body as it seemed to accentuate the effect of her shiny, tanned skin.

Thinking

I first looked at the possibility of shooting into the light to create a softer, more flattering effect, but this greatly diminished the striking textural quality created by direct sunlight and I decided I liked the harsher quality of this better.

Acting

I asked my model to position herself so that the sunlight glanced at an angle across her body to accentuate the texture of the sand, but in such a way that the minimum amount of black shadow was created.

I met this young lady whilst walking across the sand dunes at the Pushkar Camel fair in Rajasthan, and I asked if I could take this impromptu portrait. I opted for a shot taken in direct sunlight, as I felt that her bright smile and dark skin would be enhanced by the quite harsh lighting which, at the time I took this picture in late afternoon, had partly mellowed, and was further softened by the reflective surroundings.

Technical Details
35mm SLR Camera with an 75–300mm zoom lens and Fuji Provia.

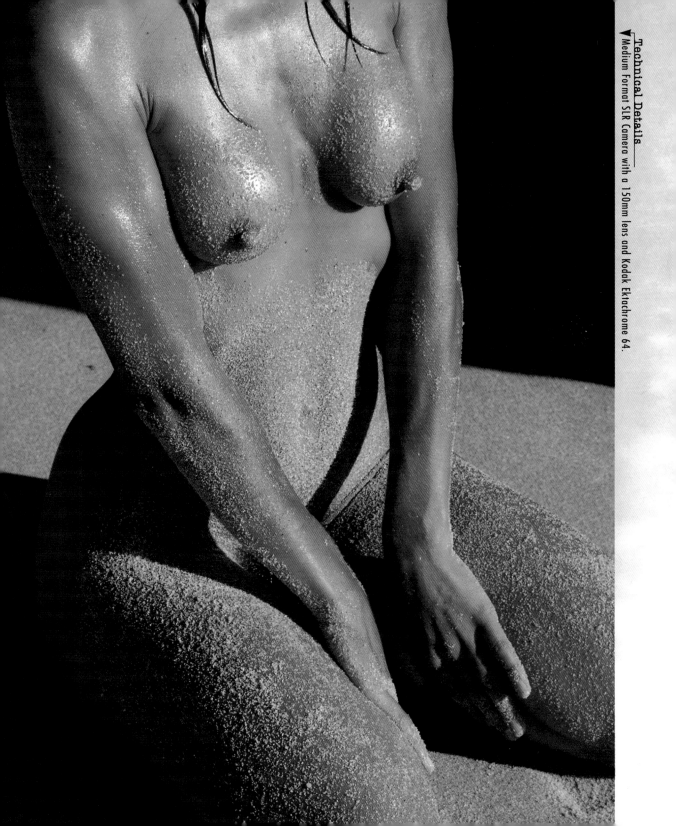

Technical Details
Medium Format SLR Camera with a 150mm lens and Kodak Ektachrome 64.

Controlling Contrast

Excessive contrast is one of the most likely problems you'll face when shooting in daylight, especially on sunny days and when shooting head-and-shoulder portraits. Too much contrast results in images with little or no detail in both highlights and shadows. With portraits, it can also create undue emphasis on skin texture and serve to exaggerate blemishes, producing distinctly unflattering results.

Seeing

This portrait was taken in very strong sunlight and I needed to find a way of reducing the contrast and to create a more pleasing quality of light.

Thinking

I asked my model to sit with her back to the sun, which has created the highlights on her hair and shoulders. But the main part of the image was now in quite deep shadow and the exposure required to produce a good skin tone would have resulted in the highlights being completely bleached out.

Acting

To overcome this problem I placed a large sheet of white polystyrene as close as possible to the model, and angled it so that it reflected the sunlight back into the shadows and reduced the image's brightness range.

Rule of Thumb

The choice of viewpoint, the model's pose and the way in which the image is framed can all affect the overall contrast of the image. When the subject is lit strongly you can limit the contrast of the image by using these factors to ensure that you either include only a small area of highlight or a small area of shadow in your frame, and you'll then have to calculate your exposure accordingly.

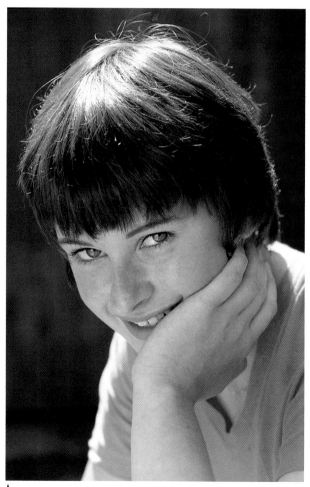

▲Technical Details
35mm SLR Camera with an 75–300mm zoom lens, an 81A warm-up filter and Fuji Provia.

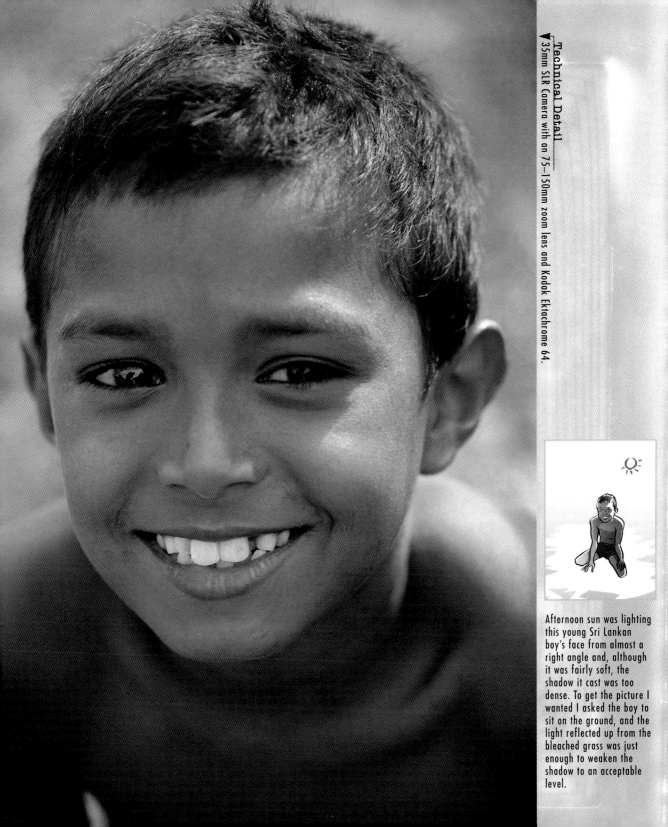

Technical Detail
35mm SLR Camera with an 75–150mm zoom lens and Kodak Ektachrome 64.

Afternoon sun was lighting this young Sri Lankan boy's face from almost a right angle and, although it was fairly soft, the shadow it cast was too dense. To get the picture I wanted I asked the boy to sit on the ground, and the light reflected up from the bleached grass was just enough to weaken the shadow to an acceptable level.

Controlling Contrast

Seeing

To photograph this vineyard worker sorting the grapes, and to show what he was doing clearly, I needed to shoot from this viewpoint so that the grapes could fill the foreground and I could see the action.

Thinking

From this position, however, the strong, early-morning sunlight was very harsh, and it created an image with extremely high contrast, ensuring that the scene was impossible to photograph conventionally.

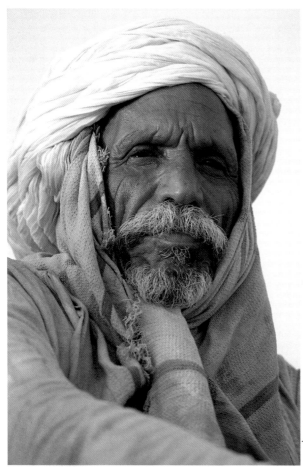

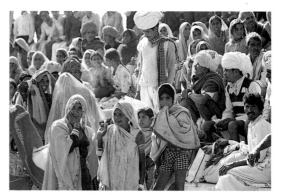

This strongly-lit and brightly-coloured scene, taken at the Pushkar Camel fair in Rajasthan, would have become harsh and discordant had I shot with the sun behind me. Shooting into the light greatly reduced the contrast but I needed to compensate the exposure, giving the picture one-and-a-half stops more than the meter indicated to avoid my results being unacceptably dark.

Technical Details
35mm SLR Camera with an 75–300mm zoom
lens, an 81A warm-up filter and Fuji Provia.

Lit from almost right angles, this man's face would have recorded as a very contrasty image in normal circumstances. But the soft light thrown by the slightly hazy afternoon sun, the reflective surroundings of the sand and his white robes, together with his dark skin, have produced an image with a pleasing quality.

Technical Details
35mm SLR Camera with an 75–300mm
zoom lens and Fuji Provia.

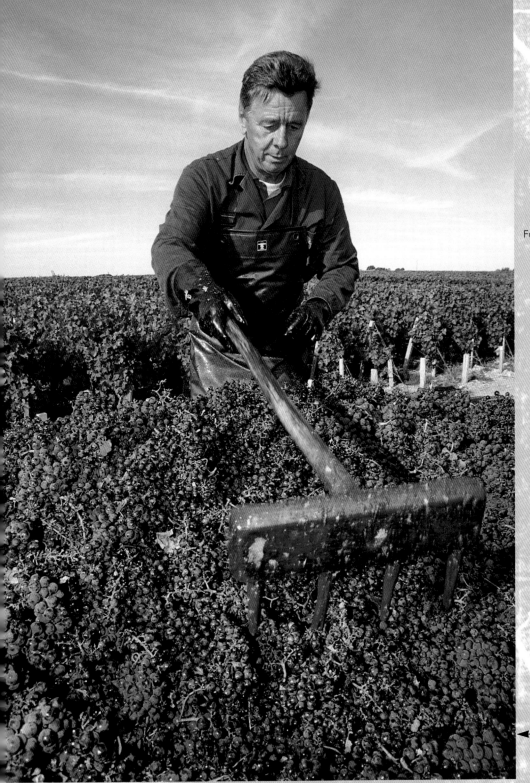

Acting

For this reason I decided to use **fill-in flash,** provided by a small portable flash gun mounted on the camera. I used the auto-exposure flash system, but set the flash **one third of a stop** down from its full setting to ensure that it lightened the scene without becoming detectable. By fitting a **wide-angle** lens and taking up a close viewpoint I was able to accentuate the **perspective** while ensuring that the flash was close enough to my subject to be effective.

Technical Details
35mm SLR Camera with a 17–35mm zoom lens and Kodak Ektachrome 100 SW.

Shooting on Cloudy Days

In many ways a cloudy or overcast day is more suitable for photographing people. The light is softer and more flattering for head-and-shoulder portraits, and its quality helps subjects from becoming fussy and confusing, particularly the more distant and detailed ones. It's especially useful light to use when you're photographing subjects which have bold colours, or strong visual elements like pattern and texture, the effects of which can easily be diminished by the bright highlights and dense shadows which sunlight creates.

Seeing

I saw this old building in the French town of Arbois on a very dull, overcast day, when many possible subjects I had considered had simply been lit in too flat a way to produce a good quality image.

Thinking

I thought this scene might still work, however, in spite of the fact that it was very softly-lit and there were no strong colours. But there was a strong element of both texture and pattern in the scene and the very dark tones inside the windows gave the impression of more contrast.

Acting

I used a long-focus lens to isolate a small area of the scene and framed the shot so there was a feeling of symmetry within the image, while the viewpoint also allowed me to place the lady close to the intersection of thirds.

Although shot on a cloudy day with very soft lighting, this scene, taken in a narrow street in Colmar, contains enough contrast for the image to be pleasing, partly because of the subject's inherent tones and partly because the overhead lighting has created some well-defined shadows.

Technical Details
35mm SLR Camera with an 35–70mm zoom lens, an 81A warm-up filter and Kodak Ektachrome 64.

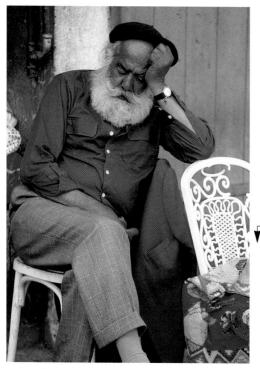

The soft light of an overcast day is ideal for subjects like this, seen at the Flea Market in Paris, as the inherent contrast and bright colours in the scene ensure a bright, punchy image while the absence of direct sunlight enables distracting highlights and shadows to be avoided.

Technical Details
35mm SLR Camera with an 75–300mm zoom lens, an 81A warm-up filter and Fuji Provia.

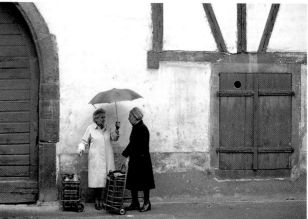

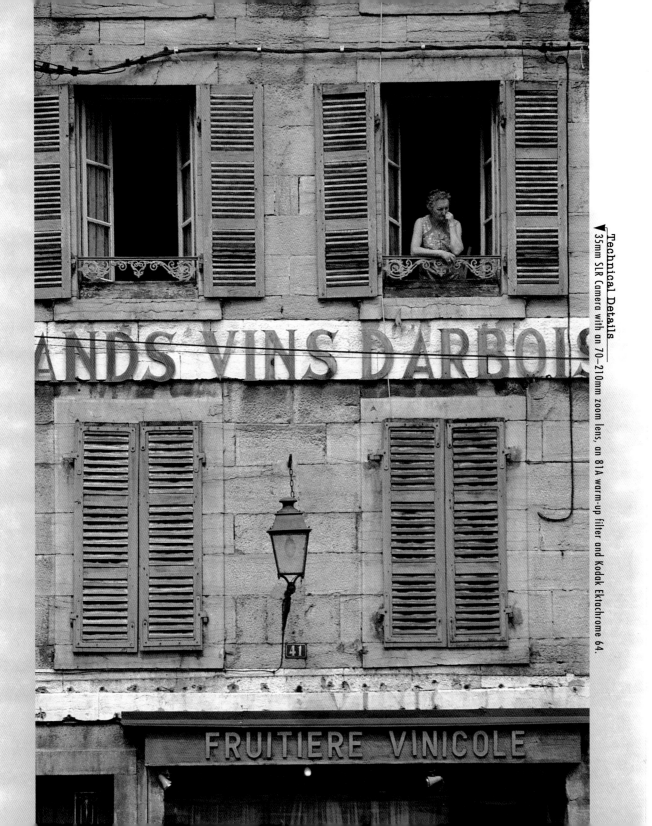

Technical Details
▼ 35mm SLR Camera with an 70–210mm zoom lens, an 81A warm-up filter and Kodak Ektachrome 64.

Shooting on Cloudy Days

Seeing

As you can see, this shot was taken on a very cloudy day with flat lighting. The overhead light was unattractive for the model, but I liked the moody sky.

Thinking

I decided that I might be able to improve matters by using flash to pick out the model. By doing this, and then reducing the exposure for the ambient light, I could also increase the image contrast.

Technical Details
Medium Format SLR Camera with an 150mm zoom lens, an 81A warm-up filter and Kodak Ektachrome 64.

Technical Details
Medium Format SLR Camera with an 150mm lens, an 81A warm-up filter and Kodak Ektachrome 64.

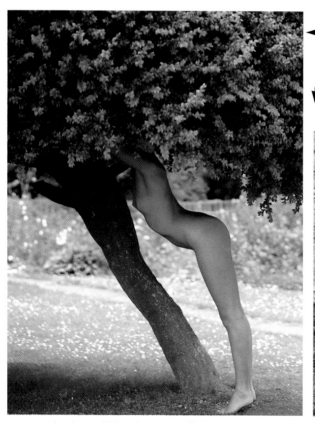

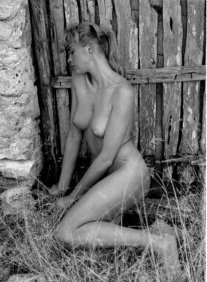

This nude shot was taken on a cloudy day and the soft light has created an attractive skin quality, while the rich textures of the grass and the weathered wooden door have added a useful degree of contrast to the image, and also provide an interesting background for the shot.

This shot would have been very difficult to take on a sunny day as the brightness range between the shaded body and the sunlit background would have been far too great. The very soft lighting, and the weak shadows it has produced, has made it possible for good detail to be recorded in both the shadow and highlight areas, while excellent skin tones have also been created.

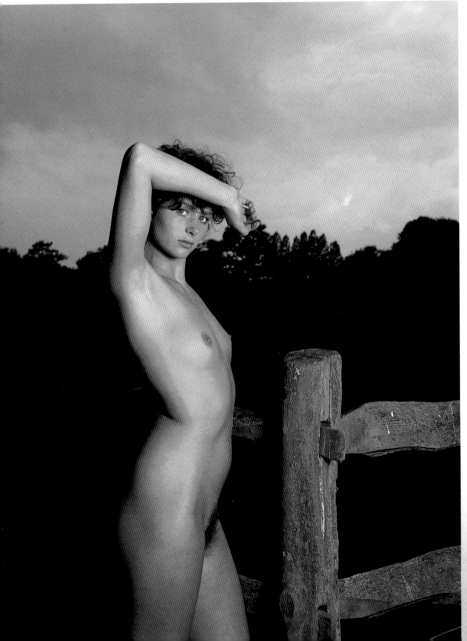

Acting

I set up a portable flash unit to the right of the camera, quite close to the model, and diffused it with a soft box. Having calculated the aperture I needed for the correct flash exposure, I then set the shutter speed so the background and sky were underexposed by two stops.

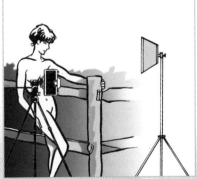

This diagram shows the lighting set-up for this shot.

Using Colour

Most photographers react strongly to a colourful subject, but unless some thought is given to the composition of the image the results can easily be disappointing. For the greatest impact, colour should be used selectively in an image. Photographs which contain a broad range of colours tend to have a fussy and confusing quality which can easily overwhelm the subject.

Seeing

This shot of a Balinese lady making satay sticks appealed to me as much for the scene's colour quality as it did for the interest of the subject.

Thinking

The combination of blue and green is ubiquitous in nature but, for some reason, when it occurs in other circumstances I find it particularly interesting. It was the way in which these colours almost completely dominated this scene which made me react to it, while the small contrasting detail of the satays was also interesting.

Acting

I used a wide-angle lens from a fairly close viewpoint and framed the shot so that the woman was placed in one half of the image, while I included part of the window frame on the opposite side to balance the composition.

▲ Technical Details
35mm SLR Camera with an 35-70mm zoom lens, an 81A warm-up filter and Fuji Provia.

The juxtaposition of the shop sign and the smiling couple appealed to
me in this shot, taken in Sri Lanka. But it was the bold colour contrast
between the sign and the boy's shirt which clinched it for me.

Technical Details
▼ 35mm SLR Camera with an 35–70mm zoom lens, an 81A warm-up filter
and Kodak Ektachrome 64.

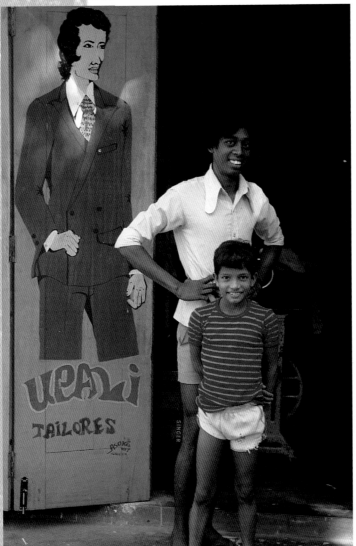

It was the powerful, jarring contrast between the colours
of the robes worn by these two Moroccan ladies which
appealed to me. The fact that they were facing away from
the camera has heightened the effect, as it has reduced
them to just very bold-coloured shapes.

Technical Details
▼ 35mm SLR Camera with an 28–70mm zoom lens and
Kodak Ektachrome 100 SW.

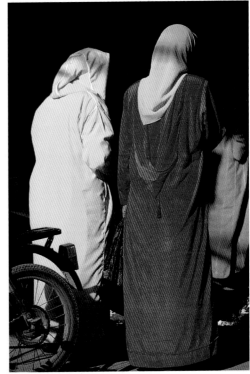

Using Colour

Seeing

This lady was studying form during a lull in the races at **Longchamps** during the Paris Grand Prix. It's very much the sort of shot which appeals to me, and it was an easy one to **shoot unseen** as she was so engrossed in her paper.

Thinking

My first thought was to **zoom in closer** so that she practically **filled the frame,** but I then took more notice of the fence behind her and the effect its colour and texture had when combined with the grass in the foreground.

Acting

I decided to switch to a **wider angle**, and to include much more of the fence together with a **larger area** of the foreground, framing the shot so that she was placed in the **bottom half** of the frame.

This was one of those fleeting opportunities seen in a Moroccan village. I'd already noticed the beautifully-coloured wall when I saw this schoolgirl approaching, and the sunlight on her yellow scarf created a bold contrast against the dark-toned wall.

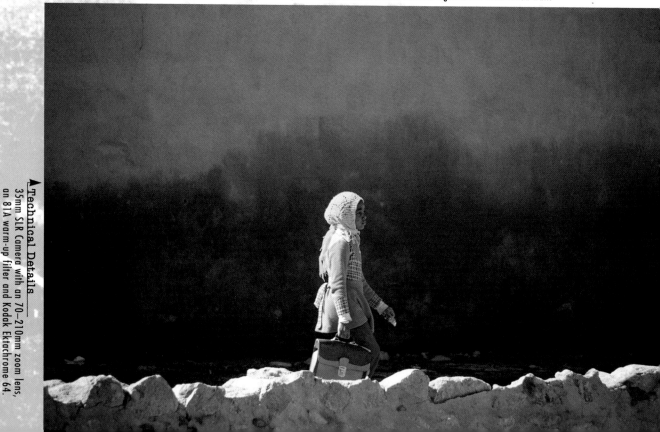

Technical Details
35mm SLR Camera with an 70–210mm zoom lens, an 81A warm-up filter and Kodak Ektachrome 64.

It's important to appreciate just how much colour can influence the mood of a picture. Images in which the warm colours – such as red, yellow and orange – predominate will tend to have a cheerful and inviting quality, whereas photographs where the cooler hues of blue, greens and purple are dominant will generally create a more subdued and introspective mood. In a similar way, bright, bold colours will have a lively and assertive quality, while soft pastel colours will suggest a more gentle or romantic atmosphere.

Technical Details

▼ 35mm SLR Camera with an 35–70mm zoom lens, an 81A warm-up filter and Kodak Ektachrome 64.

It was very dull day when I spotted this sub-aqua enthusiast contemplating a dive. The very soft lighting has accentuated the contrast between his red wet suit and the dark grey water, creating an image with a considerable degree of impact.

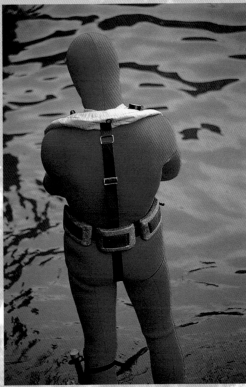

▲ Technical Details

35mm SLR Camera with an 35–70mm zoom lens, an 81A warm-up filter and Kodak Ektachrome 64.

Using Shape, Form & Texture

The art of composition hinges on the ability to look beyond the subject, and to see it in terms of its visual components. The qualities of colour, form, texture, pattern and shape make up the essential structure of an image, and are the things which determine the basic nature of a composition. When these elements have been clearly identified, it becomes much easier to see how the image can be arranged within the frame to create the most impact.

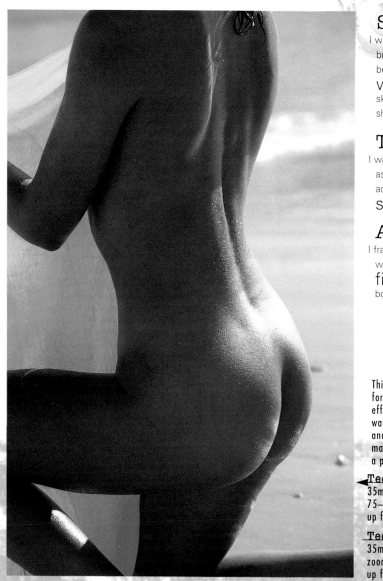

Seeing

I was shooting pictures of this male model for a holiday brochure when I saw him stretching his back between set ups. I thought the combination of his well-tuned muscles and richly tanned skin had the potential for a semi-abstract shot.

Thinking

I wanted the picture to be impersonal, so I asked him to face away from the camera and then adopt this pose to create a more interesting shape.

Acting

I framed the shot quite tightly so that his trunks were not included, and used a polarising filter to increase the colour saturation of both his skin and the blue sky.

This shot depends on shape and form as well as texture for its effect. I framed it tightly in this way to emphasise these qualities, and to depersonalise the image to make it more of an abstract than a portrait.

Technical Details
35mm SLR Camera with an 75–150mm zoom lens, an 81A warm-up filter and Kodak Ektachrome 64.

Technical Details
35mm SLR Camera with an 35–70mm zoom lens, polarising and 81A warm-up filters with Fuji Provia.

The contrast between the model's brown skin and the bright blue of the water has emphasised the element of shape in this nude shot, while the pattern effect created by the highlighted ripples has added a further degree of interest.

Using Shape, Form & Texture.

Seeing

This man is one of several water vendors who can be found in the square of Jemma el Fna in Marrakech. Their purpose nowadays is to stand around to have their picture taken, but the light in the square is invariably harsh and the surroundings incredibly busy and cluttered.

Thinking

I wanted to photograph this particular man, but there was little chance of producing a worthwhile image because of the poor lighting and muddled background.

Acting

I asked him to accompany me, for a modest fee, to a shaded area where there was a piece of canvas draped over a wall, and I placed him in front of this. The plain background has helped to accentuate the shape of his extraordinary head gear, while the softer light has revealed the subtle textures of skin, fabric and metal.

Technical Details
▼ 35mm SLR Camera with a 80–200mm zoom lens an 81A warm-up filter and Fuji Provia.

I saw this small child in a Masai village in Kenya, and was instantly attracted by the bold colour contrast between her jumper and the surroundings. But I realised that the shapes created by the painted wall and the pole were also very striking, and so I framed the image to make the most of these.

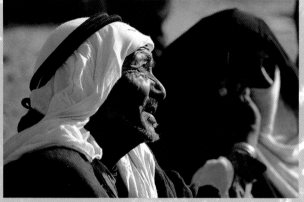

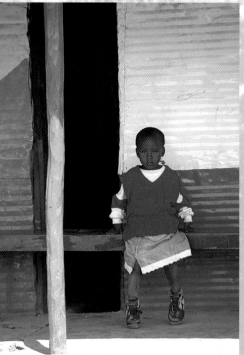

It is the shape of this Arab man's strong profile which is the key element in this shot, and I chose a viewpoint so that it was set against a dark, featureless area of the background in order to accentuate it.

Technical Details ◢
35mm SLR Camera with a 75–150mm zoom lens an 81A warm-up filter and Kodak Kodachrome 64.

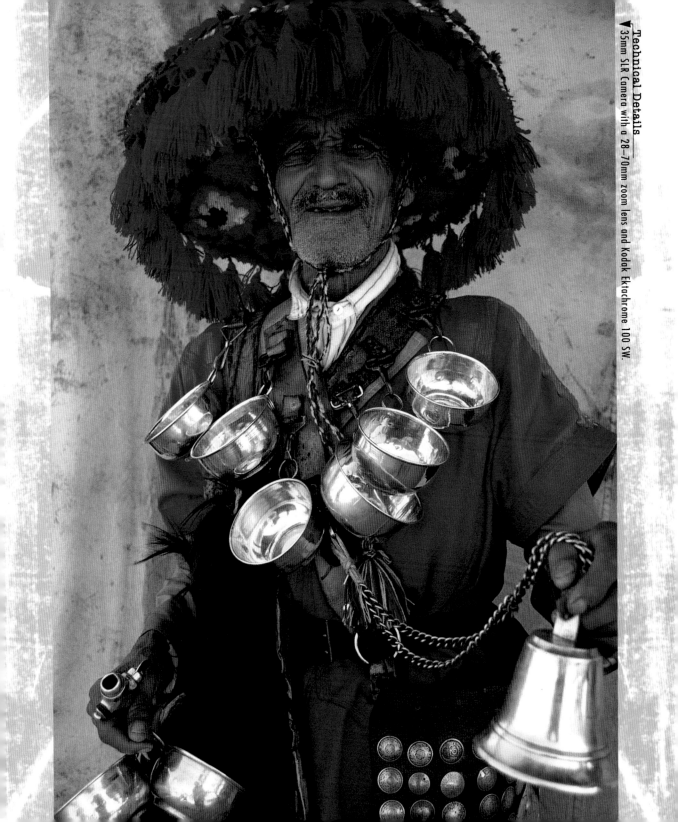

Technical Details
▼ 35mm SLR Camera with a 28–70mm zoom lens and Kodak Ektachrome 100 SW.

Capturing & Moment

Photography's unique quality is its ability to record a fleeting moment in time, something not possible using any other visual medium. Often a fraction of a second can make a huge difference to the outcome of a photograph. The momentary expression, passing gesture or the dramatic moment captured during an action-packed event can all make great pictures, but success is dependent upon the photographer's ability to be able to recognise and to capture that significant moment.

This diagram shows how the composition would have been altered had the photo been taken seconds earlier or later.

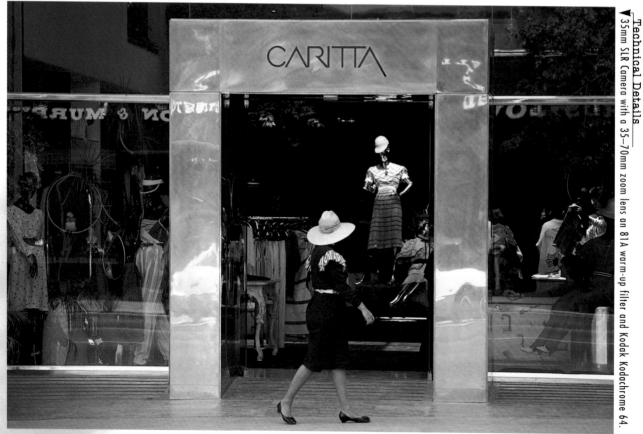

Technical Details
35mm SLR Camera with a 35–70mm zoom lens an 81A warm-up filter and Kodak Kodachrome 64.

▼ 35mm SLR Camera with a 35–70mm zoom lens an 81A warm-up filter and Fuji Provia.

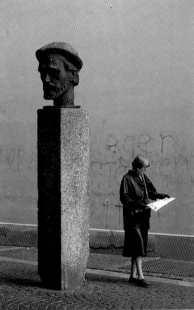

Seeing

I spotted this impressive shop front in Rodeo Drive in
Los Angeles. I was attracted by the
rectangular gold portal and the way
the interior lighting had highlighted the shop
dummy inside.

Thinking

I had taken a few shots of it before wondering if the
inclusion of a human figure might make it
more interesting. I decided to wait to see if a suitable
candidate might walk by.

Acting

This lady with her splendid hat was more than I
could have hoped for. With my image ready-
framed, I simply waited until she arrived at the
most effective spot and then fired, thanking
my lucky stars as she turned her head towards the
dummy at the crucial moment.

This shot depends
entirely for its effect
upon the juxtaposition
of the statue and the
passing woman. A
second sooner or later
would have completely
altered the composition.

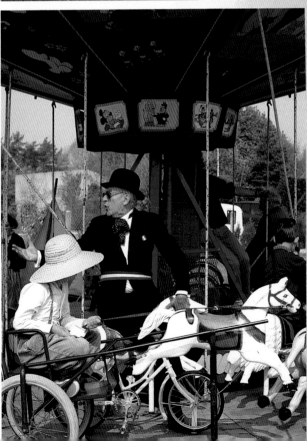

This picture was taken during a small French village
fair in which the locals had all dressed in period
costume. This fine-looking man was the mayor, and I
felt the opportunity presented by his dignified
appearance and the incongruity of his riding on the
merry-go-round was too good to miss. I was able to
wait while he went round a few times and then shot
when this backward glance coincided with him being
placed in a good position from my chosen viewpoint.

Technical Details ▶
35mm Rangefinder Camera with a 90mm lens, an
81A warm-up filter and Kodak Ektachrome 100 SW.

Capturing the Moment

▼ 35mm SLR Camera with a 35–70mm zoom lens, an 81A warm-up filter and Kodak Kodachrome 64.

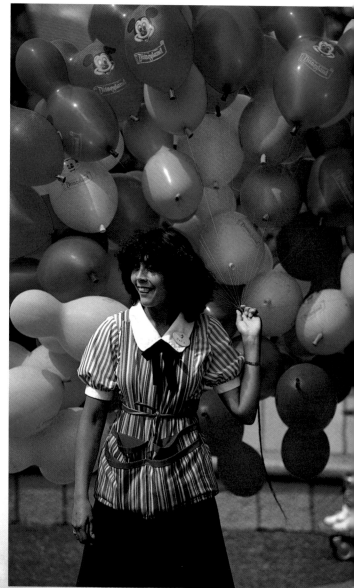

Seeing

I'd been watching this young lady selling balloons for some time while shooting in the Los Angeles Disneyland and I felt that she offered the potential for a good picture.

Thinking

It seemed to me that the most effective shot would be one where the background consisted of just balloons, and so I quietly manoeuvred myself into the best viewpoint to achieve this picture, with my lens already set to frame the shot quite tightly.

Acting

Unfortunately, however, her head was turned to the right all the time as she dealt with a small queue of customers, and this meant her face was in deep shadow. When she momentarily turned her face into the light the picture suddenly became alive, and I was able to shoot a couple of quick frames, this one featuring the best expression.

Rule of Thumb

It's a mistaken belief that motor-drives, which many cameras now feature, will allow you to hedge your bets successfully and to depend upon rapid firing to guarantee the most important moment will be recorded. In reality this rarely happens, and in most cases you will stand a far better chance of capturing the most significant moment of an action by good anticipation and a quick reaction.

Technical Details
▼ 35mm SLR Camera with a 80–200mm zoom
lens and Kodak Ektachrome 200.

I'd had my camera ready to aim at this little girl for a while as she was engrossed in a game at a children's party. But it was not until she looked up for a moment that a worthwhile picture became possible, and then only for a second or so as she became self-conscious on realising I was photographing her.

This picture has worked quite well simply because of the juxtaposition of the various elements. The players were obviously moving all the time, and there was just one fraction of a second when the figure on the far left struck this pose, and was also clearly separated from the others. This was the moment I was waiting for, and it meant I could achieve a sense of order and balance in the composition.

Technical Details
▼ 35mm SLR Camera with a 35–70mm zoom lens and Fuji Provia.

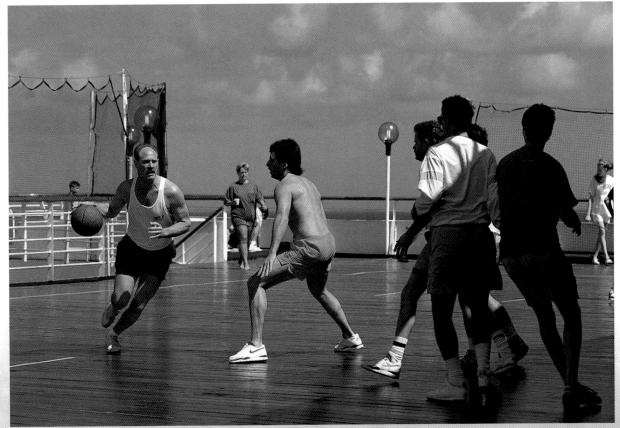

Photographing People Indoors

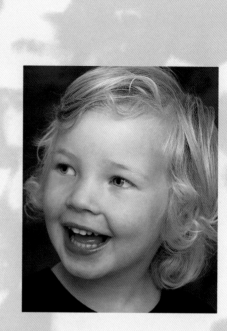

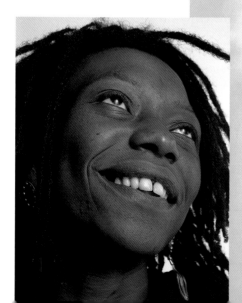

3

Taking photographs of people indoors has a number of advantages. It provides a more comfortable environment for the model, without the vagaries of weather and wind to contend with; it offers greater control over factors like lighting and backgrounds, it makes the use of props much easier and more convenient and it helps to produce photographs with a rather more formal, professional quality.

Window Light

Photographers, and manufacturers of lighting equipment, devote much of their time and effort trying to reproduce the effect of window light. It is, in fact, an ideal source of illumination for subjects like portraits and nudes and requires little more in terms of equipment and accessories than is needed for shooting pictures outdoors. Ideally, a north-facing window is best and the larger the better, as this provides a more constant light source, but almost any window will do.

Seeing

This portrait was taken using the light from south-facing French doors which were placed almost at right angles to the wall used as a background. I liked the shadow which the quite directional light was throwing from the model onto the wall.

Thinking

In order to make the shadow as well-defined as possible, and to create the most interesting shape, I asked the model to lean against the wall.

Acting

This resulted in quite dense shadows on the opposite side to the window so I placed a large white polystyrene reflector very close to her on this side and then asked her to turn her head towards the light to create more attractive modelling.

This diagram shows the set-up used to take this indoor portrait.

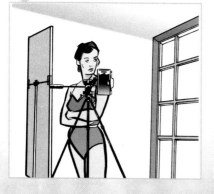

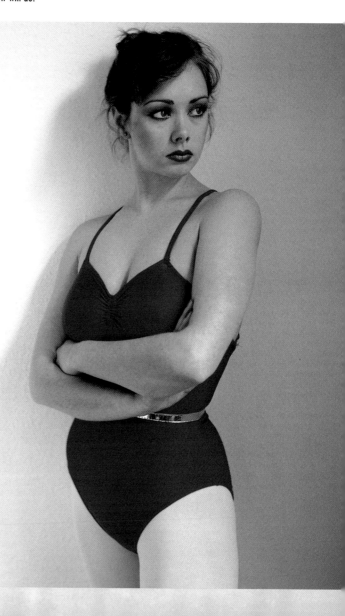

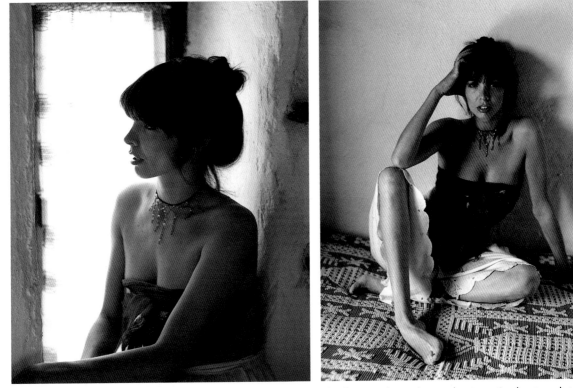

I've deliberately placed the model in front of the window for this shot as
I wanted to produce a semi-silhouette effect and was prepared to let the
window "burn out".

This shot was taken in the same location, a Greek cottage, but this time
I placed my subject at right angles to the window to create stronger
modelling. This room in the cottage had a window on each side and this
has created enough fill-in light to make a reflector unnecessary.

▲Technical Details
Medium Format SLR Camera with a 105mm lens
and Kodak Ektachrome 64.

▲Technical Details
Medium Format SLR Camera with a 105mm
lens and Kodak Ektachrome 64.

◀Technical Details
Medium Format SLR Camera with an 80mm
lens, an 81A warm-up filter and Kodak
Ektachrome 64.

Using Window Light

Seeing

This was a rather elegant room with a large north-facing window which created a quite soft, even light and enabled me to shoot without having to use a reflector.

Thinking

Because the setting itself was so attractive, I opted to use a fairly distant viewpoint and wide framing in order to use the room's interior as part of the composition.

Acting

I framed the image so that the two models were placed in the lower half of the frame and switched on the table lamp in the background to contribute an inviting warm glow to a picture which would, otherwise, have a fairly cool, bluish quality, as well as adding some light to the more shaded background.

Rule of Thumb

You can exercise a considerable degree of control over the quality of window light by the use of reflectors to fill in shadows and by using diffusing materials, such as white net curtains or tracing paper, over the window itself. Its direction can be controlled by the way you place your model in relation to the window and this can be made easier if you have a readily movable background, such as a painted board, a roll of paper suspended from a light stand or a custom-made collapsible fabric background such as Lastolite.

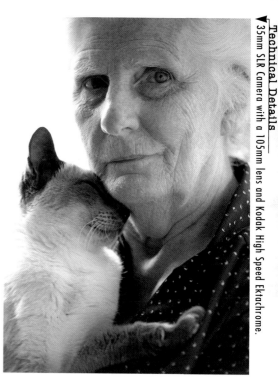

This portrait of my mother, with her favourite cat, was taken by placing her inside a bay window on a cloudy day. I liked the effect created by the soft light being directed from both sides of her face and the burnt-out window behind creating a white background.

Technical Details
▼ 35mm SLR Camera with a 105mm lens and Kodak High Speed Ektachrome.

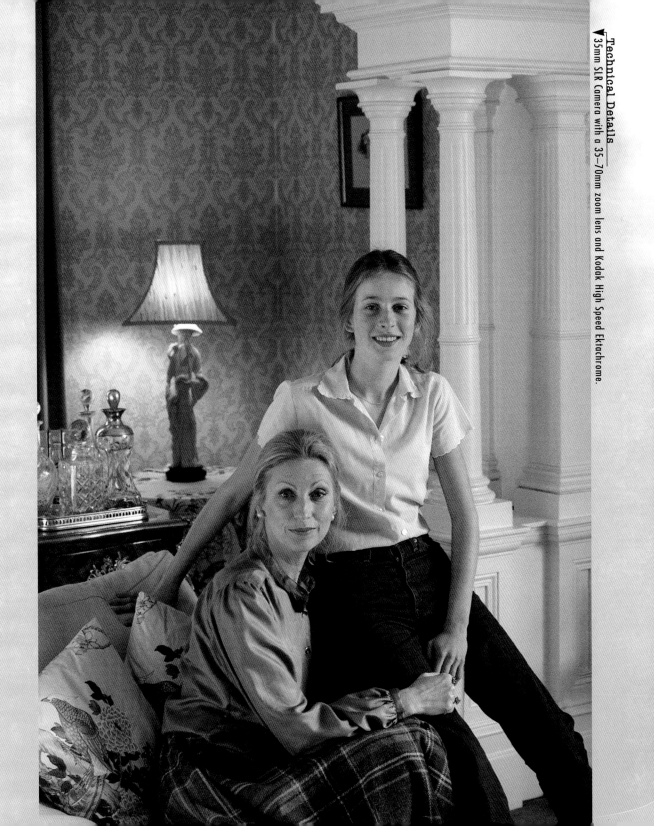

Technical Details
▼ 35mm SLR Camera with a 35–70mm zoom lens and Kodak High Speed Ektachrome.

Using Window Light

Seeing

This Moroccan man had invited me into his home and his mud-walled room was flooded with sunlight from two small windows and a partially open roof. It created a beautiful golden light because of the tinted walls, and I was taken by the fact that his skin took on a colour which almost matched them.

Thinking

I had no reflector and was reluctant to use fill-in flash so I asked the man to stand in a spot where the light on his face was soft enough to create good modelling without excessive contrast and where there was just enough light reflected from an adjacent wall to reveal some detail in the shaded side of his face.

Rule of Thumb

Fill-in flash is a useful alternative to using a reflector when the shadows cast by window light are too dense and the image is too contrasty. But be careful not to overdo it, it's best to set the flash exposure to give about one stop less than the correct exposure to retain the effect of the window light and create a natural-looking quality.

Technical Details
▼ 35mm SLR Camera with a 75–150mm zoom lens and Kodak Ektachrome 64.

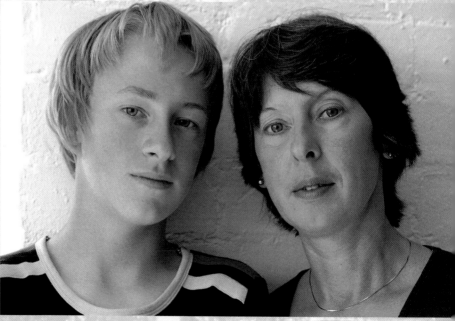

This double portrait was taken close to a large north-facing window on a bright sunny day and a small window opposite has provided enough fill-in to avoid the use of a reflector. In normal circumstances, when shooting two or more people together, I would arrange them so their heads were at different levels, but I rather liked the side-by-side effect of this mother and son picture.

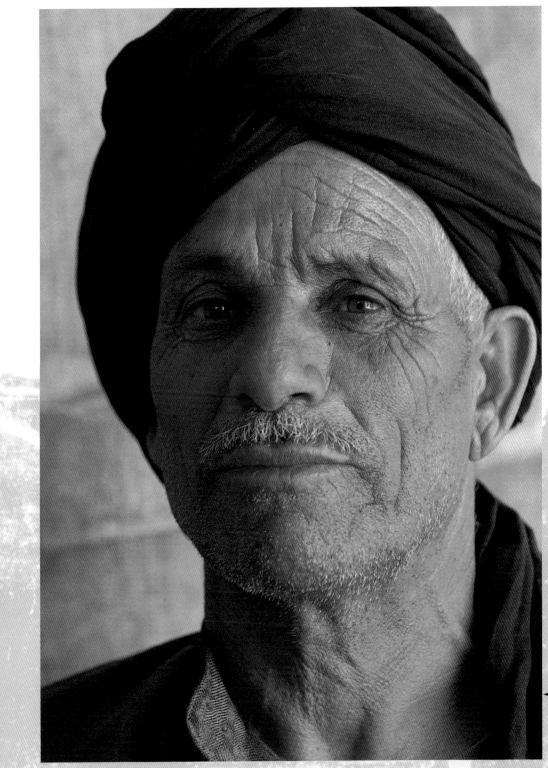

Acting I used a long-focus lens to frame the image quite tightly, from a fairly distant **viewpoint**, with just enough of the **background** visible to echo the flesh tones.

◄**Technical Details**
35mm SLR Camera with a 70–200mm zoom lens and Kodak Ektachrome 200.

Using a Flash Gun

A flash gun is a very useful accessory as it enables you to shoot pictures when there is not enough light to make normal photography possible. But pictures taken by direct flash alone can be very disappointing, often with black, featureless backgrounds and little of the atmosphere which the situation possessed. But, with a little care, a flash gun can be used to create an attractive lighting quality and produce pictures where its use is not so obvious.

Seeing

I took this portrait of a clown in his caravan where the possibilities of both lighting and choice of viewpoint were very limited.

Thinking

One largish caravan window was covered with a net curtain and I decided to use this as a background, it was virtually the only plain area available.

This impromptu shot was taken at a children's party and the room was dimly-lit from a window at one side and by an overhead light fitting. These sources alone created an unattractive effect, so I opted to use a flash gun bounced from the ceiling above my head. But I set a shutter speed which was slow enough to make some use of the ambient light and this has helped to create a more natural effect.

This illustration shows how the light from a flash gun can be bounced from a white ceiling to create a more natural effect.

Technical Details
35mm SLR Camera with a 70–200mm zoom lens and Kodak Ektachrome 200.

Acting

As the **ambient light** in the caravan was not creating an attractive **effect,** I decided to use a flash gun and placed it slightly to one side of the camera, **diffusing** it with a small soft box. I set a **shutter speed** which was slow enough to make the window **burn out** and for the light from it to create a **highlight** on the side of his face.

◄ **Technical Details**
35mm SLR Camera with a 35–70mm zoom lens and Kodak High Speed Ektachrome.

Using Available Light

There are many occasions where flash is used when it would have been better to make use of the available light, whether it is normal room lighting, window light or a mixture of both. It has the big advantage of retaining the atmosphere of a room or situation, something which flash can easily destroy. It's largely the quality of the ambient light which should dictate the use of flash as with today's very fast films its intensity is seldom a restriction.

Seeing

This picture was taken in the Casino at Baden Baden and the room was lit by a mixture of artificial light and daylight from distant windows. The artificial light was an important factor as it contributed enormously to the room's atmosphere.

Acting

I used a fast daylight film and a tripod to allow the use of a fairly slow shutter speed, as the light was not very bright and framed the shot quite tightly so the semi-silhouetted man in the foreground became the dominant element of the composition.

Thinking

The artificial light was significantly brighter than the small amount of daylight and I considered using artificial light transparency film but felt that the warm colour cast I would get from using daylight film would enhance the atmosphere and accentuate the rich colour of the gilded decor.

Rule of Thumb

When shooting with available light and the colour quality of the light sources are unknown, or mixed, and are not very bright, a fast colour negative film, such as Fuji Super G 800, can be the best choice as it is much more tolerant of colour casts and has greater exposure latitude than transparency film.

Technical Details
▼ 35mm SLR Camera with a 105mm lens and Kodak High Speed Ektachrome.

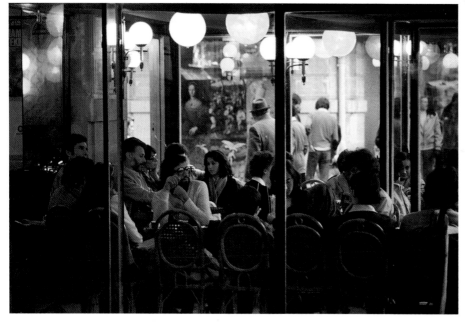

I photographed this Parisian café scene on daylight transparency film at dusk when the interior artificial lights were brighter than the residual daylight, which has resulted in the characteristic warm glow created by the colour cast.

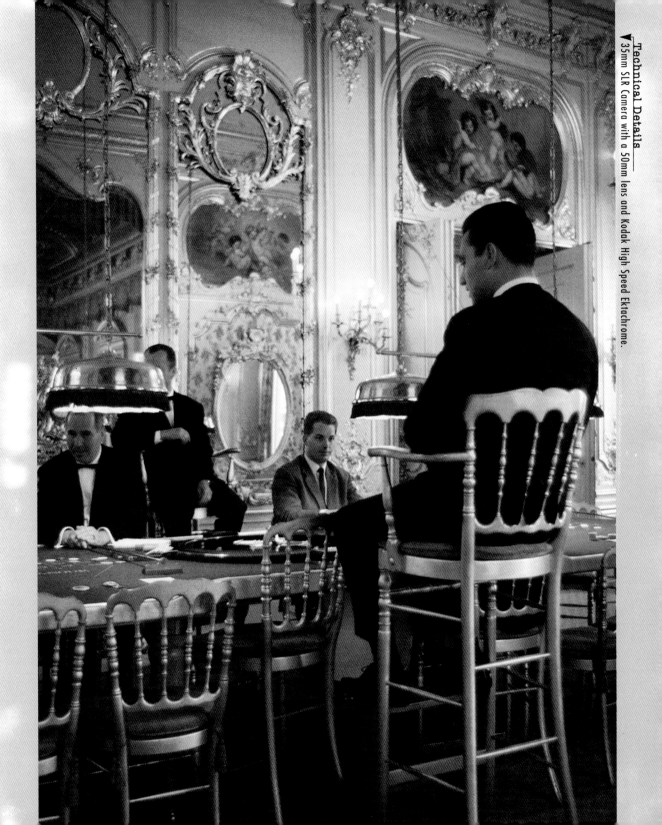

Technical Details
▼ 35mm SLR Camera with a 50mm lens and Kodak High Speed Ektachrome.

Studio Lighting Techniques

The facilities of a photographic studio provide the greatest degree of creative control over the way a subject is lit and of the content of a picture. There's a belief that studio lighting is a rather complex and difficult technique which requires a considerable amount of expensive equipment. This is simply not true, many of the best studio shots of people are taken using just one or two light sources and can be set up in a relatively small space, like a sitting room or garage.

Seeing

I considered a number of options for photographing this little girl with her mother, but the idea of making it look more like a fashion shot than a conventional family portrait appealed to me most.

Thinking

As both mother and daughter were wearing blue I chose a blue background to echo this and to make the skin tones the only contrasting colour.

Acting

I placed a large white reflector at about 45 degrees to the camera on the left and bounced two lights off it so that it was evenly illuminated and flooded the couple with a very soft, even light. I placed them close to the background so that a soft shadow was cast. The white walls of my small studio provided enough fill-in to weaken the shadows.

Technical Details
▼ Medium Format SLR Camera with a 55–110mm zoom lens and Fuji Astia.

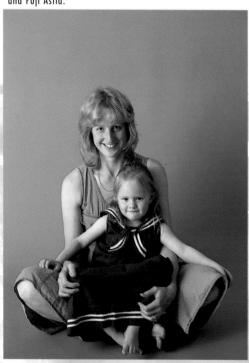

I have a natural inclination to use lighting for people with well-matured faces which will accentuate the texture and lines which the years bestow. But in this instance, I decided to use the sort of very soft, frontal lighting which would normally be used for a beauty shot. I used a very diffused light source from as close to the model's face and the camera as I could place it with a white reflector very close to her on the opposite side.

Technical Details
Medium Format SLR Camera with a 105–210mm zoom lens and Kodak Ektachrome Professional 100.

Technical Details ►
Medium format SLR 120mm macro lens and Fuji Astia.

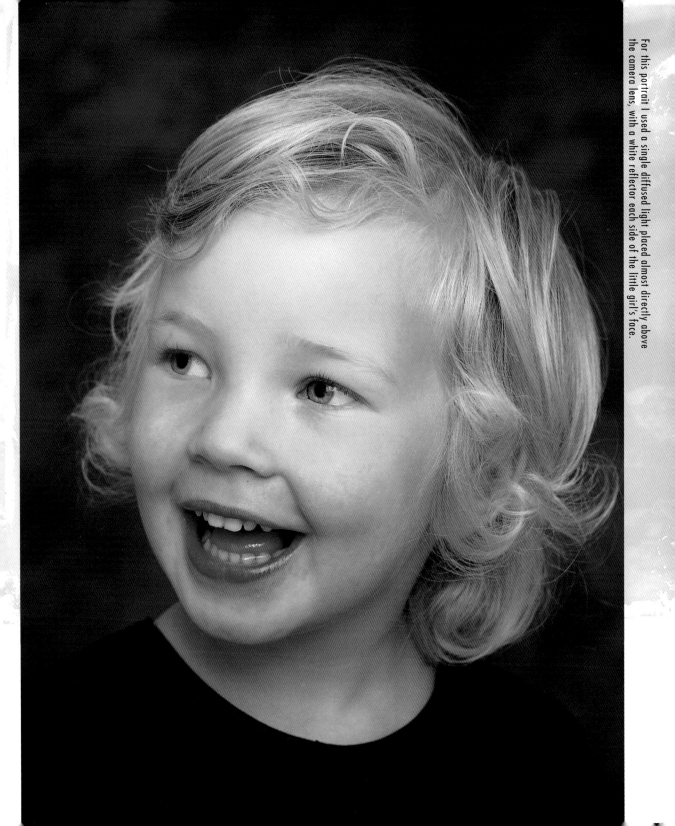

For this portrait I used a single diffused light placed almost directly above the camera lens, with a white reflector each side of the little girl's face.

Studio Lighting Techniques

Seeing

These three faces all have considerable strength and I wanted to combine them in a family group in a way which gave them equal emphasis.

Thinking

For this reason I opted for a tightly-framed image and needed to find a way of placing them so their heads were quite close together and on a similar plane.

Acting

They were lit in exactly the same way as the pictures on the opposite page but with the substitution of a painted canvas background which was lit by a separate flash. I asked the lady to take off her black top so the image consisted primarily of brown, orange and blue.

Rule of Thumb

When photographing two or more people together it usually helps to create a more balanced arrangement if you position them in a way which places their heads at different levels. I often used plastic bottle crates stacked to create a variety of levels, they can be covered with fabric to tone with the background if they are visible.

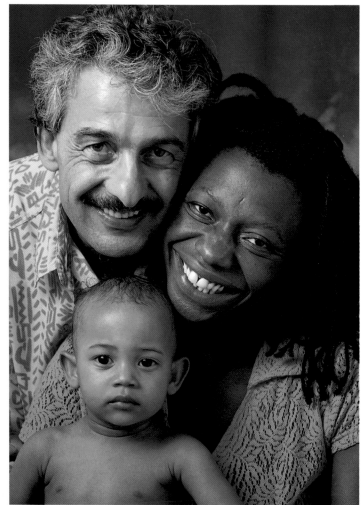

Technical Details
Medium Format SLR Camera with a 105–210mm zoom lens and Fuji Astia.
Technical Details
Medium Format SLR Camera with a 105–210mm zoom lens and Fuji Astia.

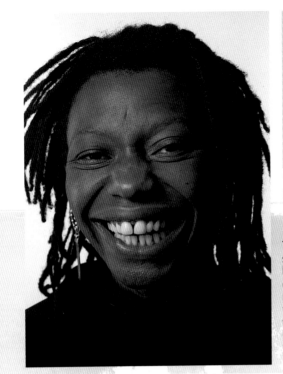

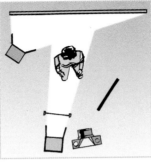

The lighting set-up for these portraits is shown here.

These two photographs were taken during the same session using the same basic lighting set-up. The close head shot was lit by a single, lightly-diffused flash placed at about 30 degrees to a line between the camera and model and I placed a black reflector close to the model's face on the opposite side to prevent reflected light weakening the shadows. Another light was aimed at a roll of white background paper and I draped a piece of black fabric around her neck and framed the image so that the image was restricted to just black, white and brown.

The longer shot was lit in the same way but less tightly framed, to accommodate the model's pose, and with the black reflector removed to allow some reflected light to weaken the shadows and show more detail.

Studio Lighting Techniques

Seeing

I'd been shooting some nudes of this model who, I thought, had a particularly lovely back and was exploring ways of photographing her in a way which emphasised it.

Thinking

I asked her to wear the black leather miniskirt and tights to create the sort of look you'd expect to see in a conventional glamour picture shot from the front. The red background was chosen because I liked the combination with the black.

Acting

But I felt the picture needed something more, so I asked the model to stand very close to the background and then lit her with a single, undiffused light from just below the camera lens, and slightly to one side, so that it cast an outline shadow from her body onto the background.

Technical Details
▼ Medium Format SLR Camera with a 150mm lens and Kodak Ektachrome 64.

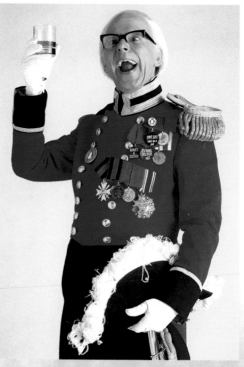

I took this picture of the late John Wells in his role as Dennis Thatcher and because of his very colourful costume I decided to keep the image quite simple. I used a white background lit by two flashes on each side and balanced them so that a slight amount of tone remained. The key light was provided by a large soft box placed almost at right angles to him with a large white reflector very close on the opposite side.

Rule of Thumb

It's helpful to appreciate that the softness of a light source and the nature of the shadows it creates is dependent upon its size in relation to the subject, as well as the way in which it is diffused. In this way, a one-metre soft box placed very close to someone's face will create a much softer quality than the same light source placed several metres away for a full-length shot.

Technical Details
▼ Medium Format SLR Camera with a 150mm lens and Kodak Ektachrome 64.

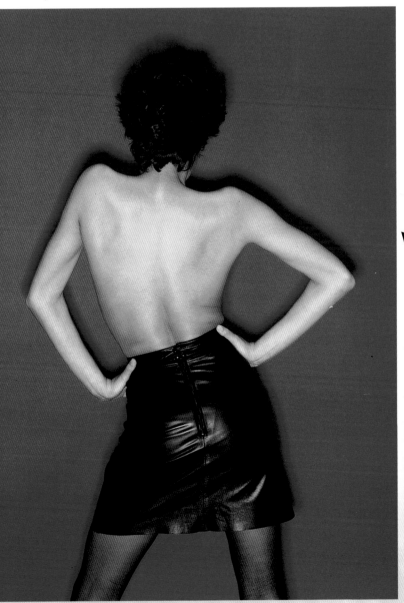

I placed a large, heavily-diffused soft box very close to this model and almost at right angles to him, with a large white reflector on the opposite side to bounce some light back into the shadows.

Technical Details
▼ Medium Format SLR Camera with a 150mm lens and Kodak Ektachrome 64.

Lighting for Mood & Effect

In most cases, lighting for subjects like portraits and nudes is designed primarily to show a model's features to the best advantage or to reveal character and emphasise qualities like form and texture. But there is also the possibility of using lighting with the prime intention of creating an unusual effect, or to establish a particular mood, and where the effect on the model is a secondary consideration.

Seeing

I wanted to photograph this model in a way which created an element of mood and started by using a soft, diffused light from one side with the intention of using a soft focus attachment over the lens to create a rather romantic atmosphere.

Thinking

I had a large piece of glass in the studio, bought for a still life, and thought I might be able to use this as a sort of texture screen. I found by spraying this with a plant mister I was almost able to achieve the effect I wanted.

Acting

But I felt that something more was needed and this was done by bouncing a blue-filtered light from a large white reflector placed to one side of the glass angled so that it created a degree of flare. I then placed a pinkish filter over the light which illuminated the model.

Rule of Thumb

The photographic process has the ability to record detail with great clarity and to convey a great deal of visual information in an image. One way of creating moody images is to use techniques which limit this quality. Lighting which creates large shadowy areas, for example, or the use of soft focus to impair the picture's clarity, are both devices which can heighten the feeling of mood in a picture.

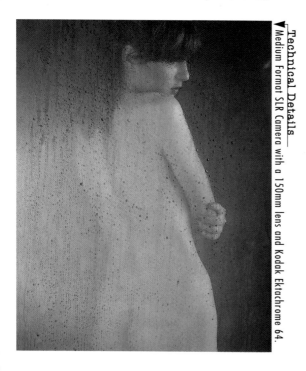

Technical Details
Medium Format SLR Camera with a 150mm lens and Kodak Ektachrome 64.

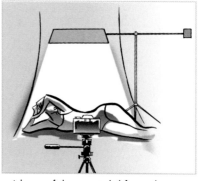

A large soft box suspended from a boom arm directly above the model has created a quite shadowy, atmospheric effect in this picture.

Technical Details
Medium Format SLR Camera with a 180mm lens and Kodak Ektachrome 64.

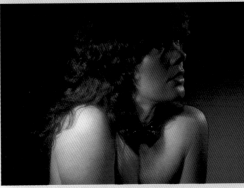

For this portrait I used pieces of coloured acetate over the light sources to create localised colour casts. The flashes were undiffused and fitted with honeycombs to concentrate the light into a small area; one with a red filter, placed behind the model to the right of the camera to create a rim lit effect, and the other, fitted with a blue filter, just behind the model on the opposite side.

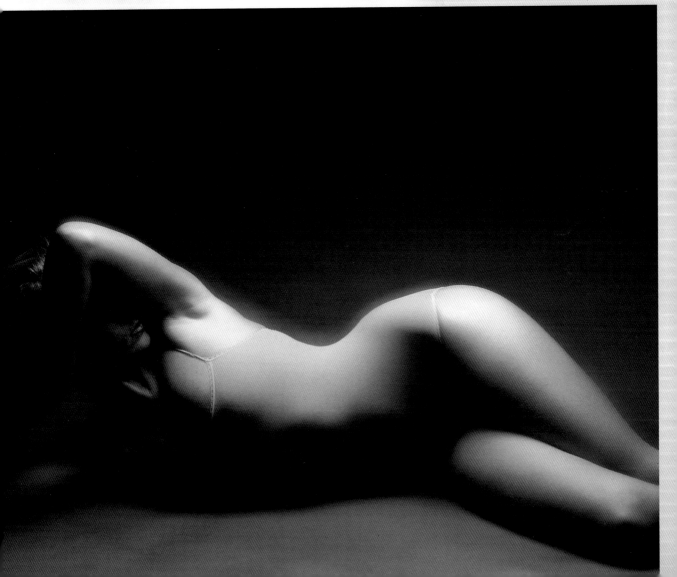

Lighting for Mood & Effect

Seeing

I wanted to avoid the more conventional approach to portrait lighting for this picture and, while experimenting, decided it looked effective when only part of my subject's face was shown clearly.

Acting

To complete the effect I then asked my model to wear a hat and a dark, polo-necked jumper so the skin tones were the only positive colour, and lit a white paper background to give a semi-silhouetted feel to the image.

Thinking

I placed a soft box close to his face and at right angles to it so that only one half was lit but had strong modelling. I then placed a black reflector very close on the other side to ensure the shadowed side of his face was quite black.

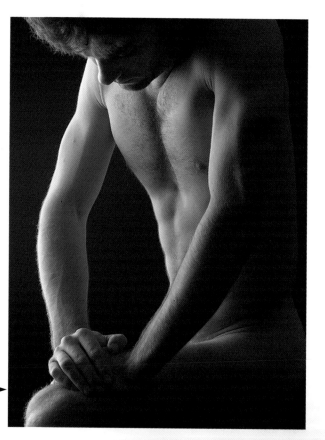

Rule of Thumb

Remember that items like props, clothes and backgrounds will all influence the mood of a picture and so too will the use of colour. It's a good idea to think about what you want to achieve and to assemble the items needed before the session begins. You can get some good ideas from studying the fashion and style magazines.

For this male nude, a large white reflector was placed almost at right angles to the model and a single flash was bounced from it to provide a very soft, diffused light. I placed a black-painted reflector on the opposite side to ensure the shadows remained black.

Technical Details ▶
Medium Format SLR Camera with a 150mm lens and Kodak Ektachrome 64.

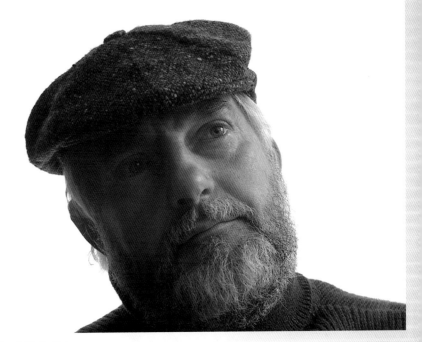

▲Technical Details
Medium Format SLR Camera with a 105–210mm zoom lens and Kodak Ektachrome Professional 100.

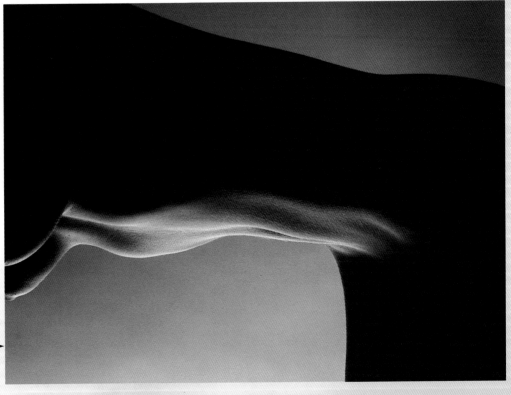

The effect for this nude was created by asking the model to kneel across two stools which were placed on a grey paper background. The lighting quality was achieved by aiming a single flash at the floor a metre or so below her so that it was bounced back under her body.

Technical Details▶
Medium Format SLR Camera with a 150mm lens and Kodak Ektachrome 64.

Character Portraits

Most photographers are pleased when their subjects like the results they produce, but with pictures for personal or editorial use this is seldom a priority. It's essential, however, that the subject is pleased with the results when a photographer is being commissioned by the person they are photographing. This often requires a degree of flattery and the down-playing of distinctive features. This is often at odds with revealing the character of a subject and it is usually images which display the latter quality which have a wider appeal.

Rule of Thumb

It's important to observe your subject carefully before deciding how best to approach the photography. Notice which facial features are strongest and make a note of distinctive gestures and expressions which you can incorporate into the pictures.

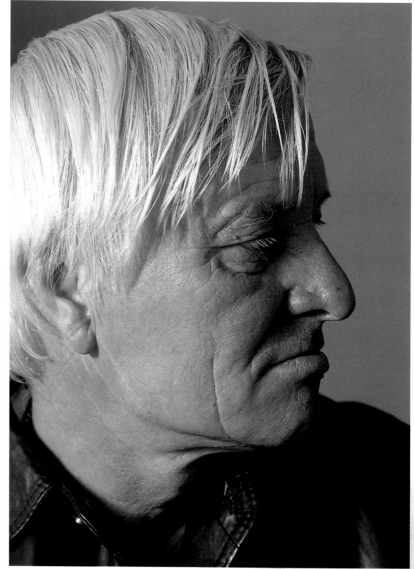

I wanted to emphasise this man's strong Slavic features and tried a variety of head positions and lighting angles before arriving at this solution. I felt a profile showed the greatest strength and I used a lightly-diffused flash from almost at right angles to the camera, on the left of his head, so the light slanted across his face to emphasise his lines and skin texture. I placed a white reflector on the opposite side to make the shadows a little lighter and chose a grey background, making his skin tones the only positive colour.

Seeing

This young man's close crop and eyebrow piercing were very obvious features but he also has a finely-shaped head with good cheekbones.

Thinking

I wanted to try and accentuate all of these things and explored a variety of poses. Ultimately, I liked this best, with his head turned down to show his scalp and his eyes downcast which, I thought, created a pensive mood.

Acting

I decided to use quite strong, directional light, which was a single flash placed a metre or so above his head at about 45 degrees to the camera and about two metres from him. I diffused it lightly by placing a wooden frame covered in garden fleece (sold for protecting plants) quite close to him. I aimed a small spot of light onto a grey paper background to create a degree of separation.

Technical Details
▼ Medium Format SLR Camera with a 105–210mm zoom lens and Fuji Astia.

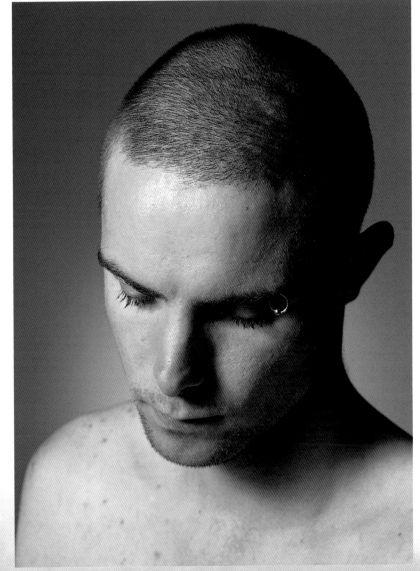

Technical Details
Medium Format SLR Camera with a
105–210mm zoom lens and Fuji Astia.

Character Portraits

Seeing

I'd taken some close-up head shots of this lady but, on consideration, felt that the way she dressed and held herself was also very much part of her character and decided to approach the picture more in the style of a fashion photograph.

Acting

I wanted to take a full-length picture and to give it a more interesting look I shot from a low viewpoint using a wide-angle lens to give the image a slightly unusual perspective.

Thinking

I thought that a plain grey background would create a very pleasing effect with the soft, pinkish colour of her coat and decided to light her softly, but from an acute angle, so there were strong shadows on her and the background. This was achieved by bouncing two lights from a large white reflector placed about two metres away and at almost right angles to her. I used a black-painted reflector on the opposite side to ensure the shadows remained dark.

Technical Details
▼ Medium Format SLR Camera with a 55–110mm zoom lens and Fuji Provia.

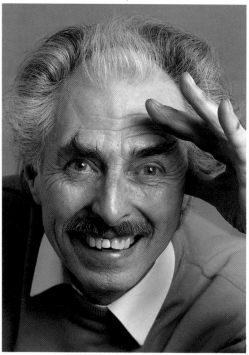

Rule of Thumb

Capturing a spontaneous expression or gesture when shooting a portrait is something which often occurs quite naturally but you can also provoke such moments and be ready when they occur. It's best to avoid directing your model in an obvious way, such as saying, "look over there", or "smile please", but rather contrive such reactions by your conversation and indirect means as this will tend to create a more natural response.

This portrait was lit very simply using a single flash diffused by an umbrella and placed quite close to him, at an angle of about 45 degrees and just above his eye level. The picture's appeal is due solely to his extrovert character and spontaneous expression.

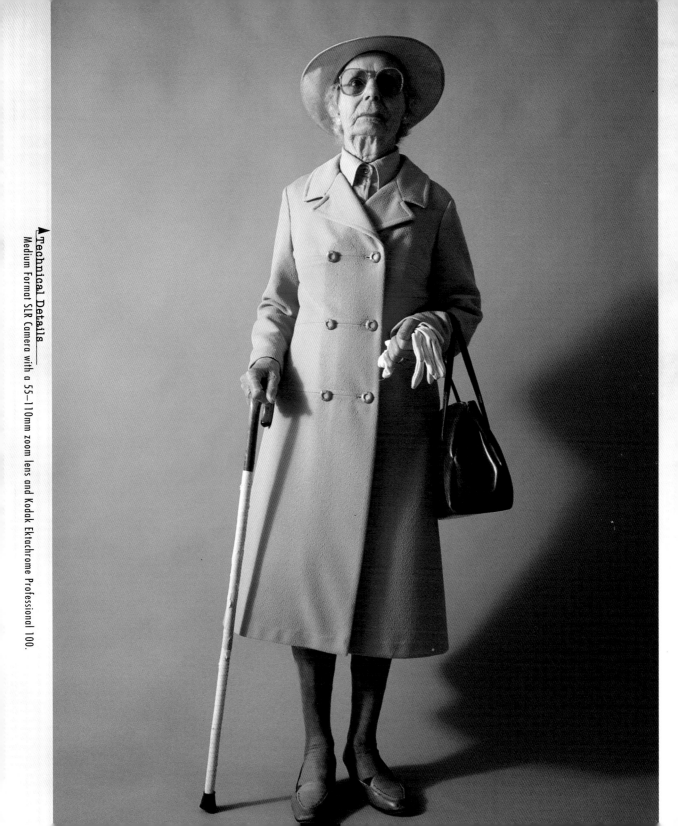

▲ Technical Details
Medium Format SLR Camera with a 55–110mm zoom lens and Kodak Ektachrome Professional 100.

Character Portraits

Seeing

This portrait was the result of looking for a way of emphasising my model's **strong features** and deeply **tanned** skin, along with the desire to avoid the more **conventional** approach to lighting.

Thinking

The majority of portraits are lit with the **light** source level with, or slightly **above**, the model's head, so the shadow from the nose falls downwards onto the **cheek.** Lighting from **below** the chin is a technique often used, in film-making to create a sinister look, I call it **Dracula** lighting, but I felt a modified form of this might be effective in this case.

Acting

I placed a large white reflector on the **floor** at the model's feet, and angled upwards, and then aimed a single flash at it so that a soft, diffused light was **projected up** from under his chin. I placed another reflector close to him on the right to bounce some light back into the **shadows** and lit a blue paper background with a **small spot** of light. I asked him to take off his shirt, to **restrict** the image to just flesh tones and blue, and to adopt this pose in order to add a touch of **drama** and fill the landscape format.

Technical Details

▼ Medium Format SLR Camera with a 105–210mm zoom lens and Fuji Astia.

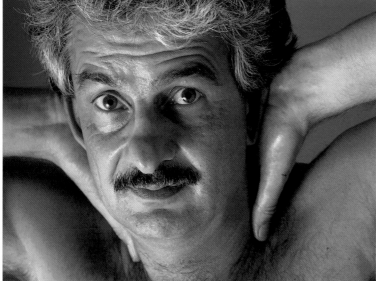

The illustration shows the lighting set-up for this portrait.

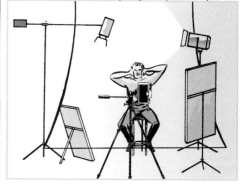

This lady is seldom seen without a smile and I shot this portrait in an effort to capture this quality and to emphasise the whiteness of her teeth and eyes against her dark skin. I used a lightly-diffused flash aimed almost directly at her nose, with a black reflector on the opposite side to keep the shadows dark. I used a separate light to illuminate a white paper background.

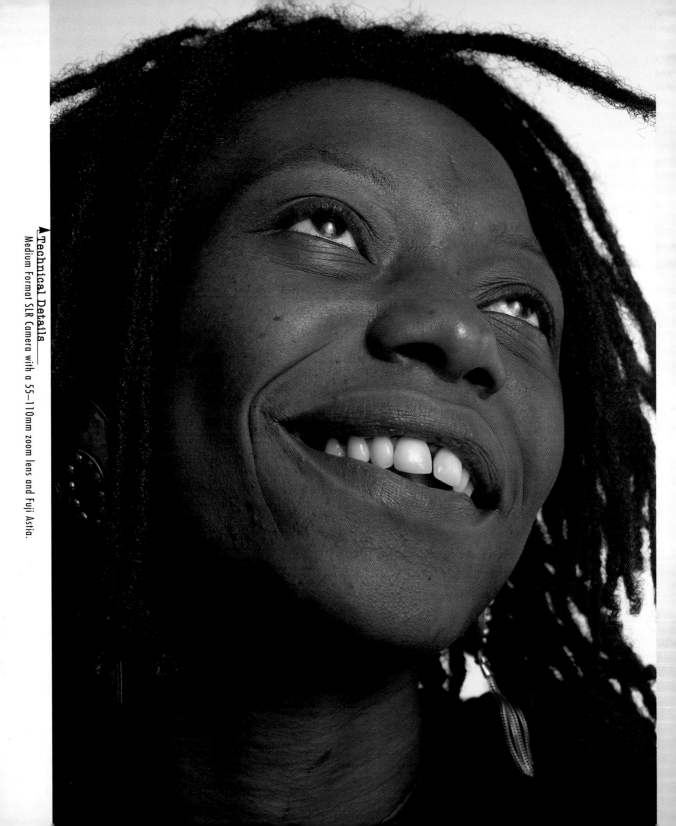

▲Technical Details
Medium Format SLR Camera with a 55–110mm zoom lens and Fuji Astia.

Beauty Photography

In many respects, beauty photography is the converse of character portraits, in that many of the qualities which are desirable for the latter are to be avoided at all costs for the former. Lighting for beauty shots is usually designed to produce only very small, faint facial shadows and to virtually eliminate skin texture.

Rule of Thumb

A technique often used by beauty photographers to create flattering images and flawless complexions is to ask the model to wear a quite thick, pale skin make-up with dark lip colour and eye make-up and to use a degree of over exposure.

Seeing

I wanted to capture the open, sunny smile and the very fresh, unselfconscious, girl-next-door looks of this lady in my picture and decided to adopt a very straightforward approach.

Thinking

But I also wanted the picture to have the sort of quality one associates with magazine covers and cosmetic ads and used the type of lighting set-up which might be used for images like these.

Acting

I arranged two large white reflectors close to her each side of the camera and angled inwards, like a V shape, with a small gap for the camera lens to see through. Using a boom arm, I then suspended a flash behind her and aimed it at the reflectors, using barn doors to prevent this light spilling onto her, and ensuring that the lens was shielded from flare. I also placed another reflector under her chin.

This picture was lit by placing a soft box each side of the camera lens with a reflector positioned close up under the model's chin.

Technical Details
Medium Format SLR Camera with a 105–210mm zoom lens and Fuji Astia.

Technical Details
Medium Format SLR Camera with a 150mm lens and Kodak Ektachrome 64.

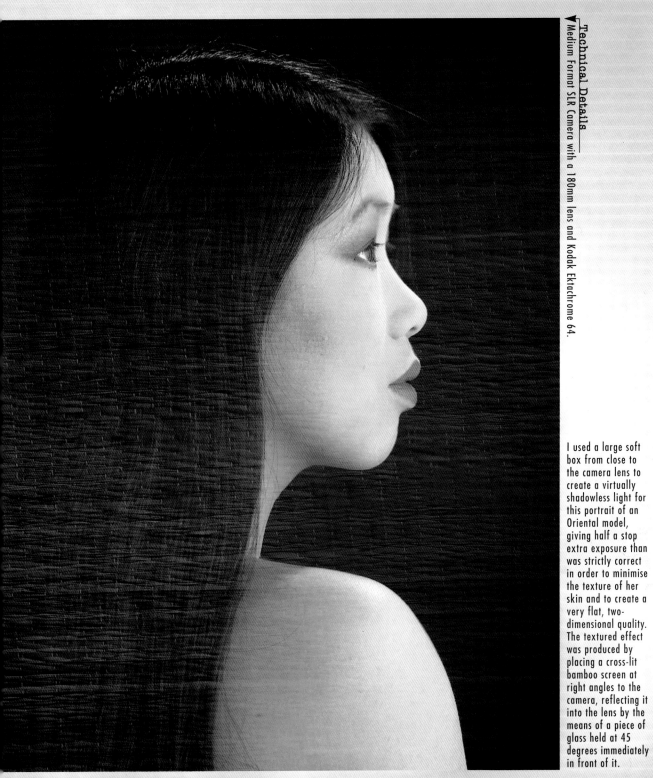

I used a large soft box from close to the camera lens to create a virtually shadowless light for this portrait of an Oriental model, giving half a stop extra exposure than was strictly correct in order to minimise the texture of her skin and to create a very flat, two-dimensional quality. The textured effect was produced by placing a cross-lit bamboo screen at right angles to the camera, reflecting it into the lens by the means of a piece of glass held at 45 degrees immediately in front of it.

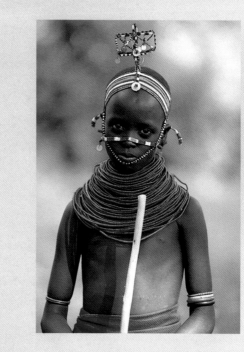

Cameras & Equipment

4

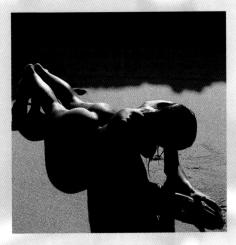

Photography of people covers a wide range of styles and techniques, ranging from the spontaneous approach to subjects like sports or reportage, to the more controlled environment of the studio portrait. In common with all crafts, having the right tools for photography can make a big difference, both to the ease of working and to the results achieved. Choosing the right equipment for your particular needs and understanding how to use it to its full advantage are the first steps.

Choosing a Camera

Formats

Image size is the most basic consideration. The image area of a 35mm camera is approximately 24mm x 36mm, but with roll film it can be from 45mm x 60mm up to 90mm x 60mm according to camera choice. The degree of enlargement needed to provide, say, an A4 reproduction, is much less for a roll film format than for 35mm and gives a potentially higher image quality.
For most photographers the choice is between 35mm, APS and 120 roll film cameras. APS offers a format slightly smaller than 35mm and for images larger than 6x9cm it is necessary to use a view camera of 5x4in or 10x8in format.

Pros & Cons

APS cameras have a more limited choice of film types and accessories and are designed primarily for the use of colour negative film. 35mm SLR cameras have the widest range of film types and accessories and provide the best compromise between image quality, size, weight and cost of equipment. Both accessories and film costs are significantly more expensive with roll film cameras and the range of lenses and accessories more limited than with 35mm equipment.
View cameras, using sheet film, provide the ultimate in image quality but are not ideally suited to photographing people because they are slow in operation and the image cannot be viewed at the moment of exposure.

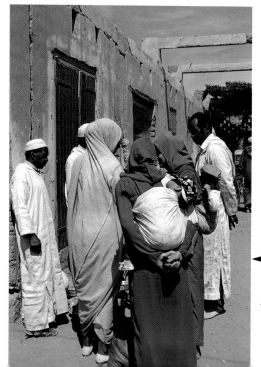

The 35mm or APS format is ideal for this type of picture, taken at a Moroccan market, as these cameras are smaller and lighter to carry than medium format and are less obtrusive in use as well as being generally faster to use and easier to hand hold.

◄ Technical Details
35mm SLR Camera with a 28–70mm zoom lens and Kodak Ektachrome 100 SW.

Technical Details ►
Medium Format SLR Camera with a 180mm lens and Kodak Ektachrome 64.

The relative sizes of the different camera formats are shown here.

Medium and large format cameras offer greater image quality for subjects like this studio nude where the larger negative or transparency can reveal more subtle tones and higher definition than 35mm or APS formats when enlarged.

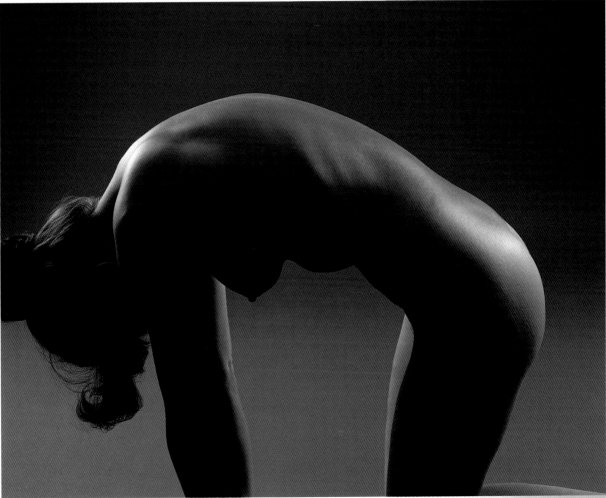

Camera Types

There are two basic choices between Roll Film, 35mm and APS cameras: the Viewfinder or Rangefinder Camera and the Single Lens Reflex, or SLR.

Pros & Cons

The SLR allows you to view through the taking lens and to see the actual image which will be recorded on the film, but the viewfinder camera uses a separate optical system. The effect of focusing can be seen on the screen of an SLR but the whole image appears in focus when seen through a viewfinder camera.

Generally, facilities like autofocus and exposure control are more accurate and convenient with SLR cameras and you can see the effect of filters and attachments. SLR cameras have a much wider range of accessories and lenses available to them and are more suited to subjects like sports when very long-focus lenses are needed.

Viewfinder cameras, such as the Leica or Mamiya 7, tend to be lighter and quieter than their equivalent SLRs and are often the choice of photo-journalists because they are less noticeable in use and not so intrusive.

Underwater or weatherproof cameras can be a useful tool for those photographers interested in subjects such as adventure and water sports, where a more conventional camera would be very vulnerable to damage.

I used an autofocus viewfinder camera for this spontaneous shot taken in an African market, where its fast action, quiet operation and small size allowed me to shoot unseen.

Technical Details
35mm Viewfinder Camera with a 45mm lens and Fuji Provia.

The facilities of an SLR camera were invaluable for this nude image. The ability to see the effect of focusing on the screen enabled me to judge the depth of field accurately and ensure the building in background was sharp enough and I was able to see the precise effect of the neutral-graduated filter I used in order to make the sky a darker tone.

Technical Details
▼ Medium Format SLR Camera with a 150mm lens, a neutral-graduated filter and Kodak Ektachrome 64.

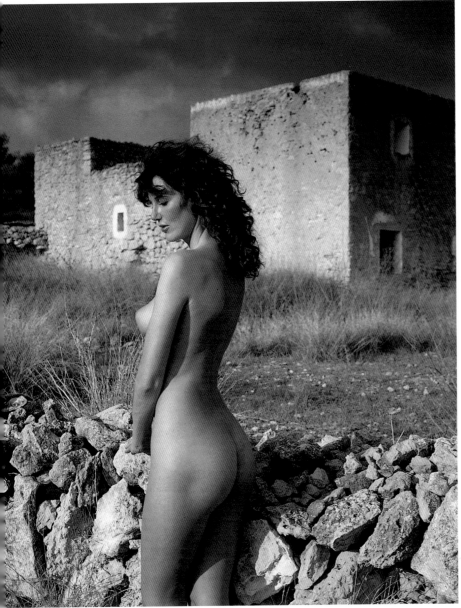

This picture was taken using a medium-format SLR with transparency film as it was to be used for reproduction in a holiday brochure. But a photograph like this for personal use, when a colour print is to be the end product, could have been taken satisfactorily on a zoom compact or APS camera.

Technical Details
▼ Medium Format SLR Camera with a 200mm lens and Kodak Ektachrome 64.

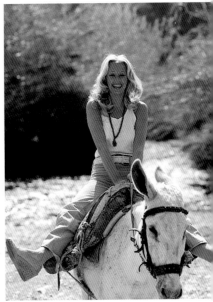

Choosing Lenses

A **standard lens** is one which creates a field of view of about 45% degrees and has a focal length equivalent to the diagonal measurement of the film format ie. **50mm, with a 35mm** camera and **80mm with a 6x6cm** camera. Lenses with a shorter focal length create a wider field of view and those with a longer focal length produce a narrower field of view. **Zoom lenses** provide a wide range of focal lengths within a single optic, taking up less space and offering more convenience than having **several fixed lenses.**

Pros & Cons

Many ordinary zooms have a maximum aperture of f5.6 or smaller. This can be quite restricting when **fast shutter speeds** are needed in low light levels and a fixed focal-length lens with a **wider maximum aperture** of f2.8 or f4 can sometimes be a better choice. Zoom lenses are available for most 35mm SLR cameras over a wide range of focal lengths but it's important to appreciate that the **image quality** will be lower with lenses which are designed to cover more than about a **three to one ratio,** i.e., 28–85mm or 70–210mm.

Special Lenses

For subjects like sports, a lens of more than 300mm will often be necessary and one between **400–600mm** is often necessary to obtain close-up images of stadium action, for example. A macro lens is also very useful for photographing very **close-up** portraits without the need for extension tubes or close-up attachments.

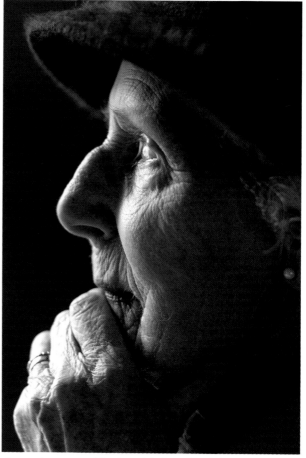

A macro lens was used for this tightly-framed head shot.

▲**Technical Details**
35mm SLR Camera with a 90mm macro lens and Fuji Astia.

Technical Details ➤
35mm SLR camera with a 75–300mm zoom lens and Fuji Velvia

Extenders can allow you to increase the focal length of an existing lens, a x1.4 extender will make a 200mm lens into 280mm and a x2 extender to 400mm. There will be some loss of sharpness with all but the most expensive optics and a reduction in maximum aperture of one and two stops respectively.

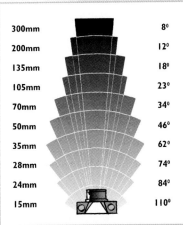

300mm	8⁰
200mm	12⁰
135mm	18⁰
105mm	23⁰
70mm	34⁰
50mm	46⁰
35mm	62⁰
28mm	74⁰
24mm	84⁰
15mm	110⁰

This diagram shows the relative fields of view produced by lenses of different focal lengths when used with the 35mm format.

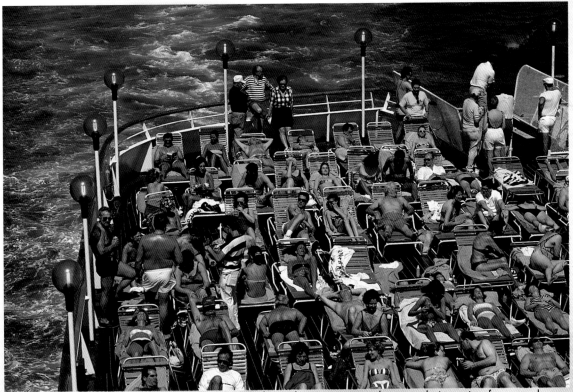

A long-focus lens was used to isolate a small area of the scene from a distant viewpoint, and to create the impression of compressed perspective, in this shot taken on a cruise ship.

Camera Accessories

There are a wide range of accessories which can be used to control the image and increase the camera's capability. Extension tubes, bellows units and dioptre lenses will all allow the lens to be focused at a closer distance than it's designed for and this can be useful to allow tightly-framed portraits to be shot when the lens in use only focuses down to a couple of metres.

A selection of filters will help to extend the degree of control over the tonal range of a black-and-white image and a square filter system, such as Cokin or HiTech, is by far the most convenient and practical option. These allow the same filters to be used with all your lenses regardless of the size of the lens mounts as each can be fitted with an adapter upon which the filter holder itself can be easily slipped on and off.

A Polarising filter is extremely useful for reducing the brightness of reflections in non-metallic surfaces, such as foliage, and will also make a blue sky record as a richer blue, creating greater relief with white clouds.

Polarisers are available in either linear or circular form. The former can interfere with some auto focusing and exposure systems – your camera's instruction book should tell you, but if in doubt use a circular polariser.

Technique

For portrait and nude photography a soft-focus filter can be effective in some circumstances. To flatter a subject, for instance, by reducing skin texture and lines or simply to help create a more romantic or glamourous mood.

Technique

A Polaroid back can be bought to fit many professional roll film 35mm and cameras such as the Canon EOS1N and the Mamiya 645. These can be extremely useful when using flash lighting as the exact effect of the set-up can be seen before the image is exposed onto normal film.

Technical Details
▼ Medium Format SLR Camera with a 250mm lens, an extension tube and Kodak Ektachrome 64.

An extension tube was used to enable the lens to be focused at a close enough distance to produce this tightly-framed portrait.

This diagram shows an extension tube fitted between the camera body and lens.

A Polaroid back was used to check the effect of the lighting set up for this portrait, before it was shot on normal film.

Technique

For portrait photography a tripod is especially useful as it enables you to aim, frame and focus the camera on your subject with the knowledge that it will remain accurately positioned. This allows you to communicate directly with your model and eliminates the need to shoot with your eye glued to the viewfinder.

Technique

A selection of colour contrast filters when using black-and-white film is useful in order to manipulate the tonal range of an image. The basic principle is quite simple. Filters of the three primary colours of red, green and blue will make objects of their own colour in a subject lighter in tone and the opposite colours darker.

Lighting Equipment

Although many cameras now have a built-in flash these are usually of restricted power and a separate flash gun can be a very useful accessory. It will be much more powerful than one built in and it can be used off camera, fitted with a diffuser and used to bounce light from a ceiling. It's best to buy the most powerful that size and budget will allow.

For those who's interest lies in subjects like portraiture and nudes, a modest range of studio lighting equipment will greatly increase the effects you can achieve with a simple flash gun. Although a small flash gun is a useful accessory, it has limited use in these fields as it is not possible to judge the effect before taking your photographs.

It's possible to buy, at relatively modest cost, two or three photoflood or tungsten halogen lights with a variety of reflectors and stands which will allow you to create a wide range of effects. In addition to the normal dish reflectors, you will also need a means of creating a diffused light and a device for restricting light spill, such as a snoot, spotlight or honeycomb.

An umbrella reflector, or soft box, is ideal for light diffusion, but you can also make a simple screen using a wooden frame covered with tracing paper, frosted acetate, nylon mesh or garden fleece. A couple of white fill-in reflectors are also invaluable; large sheets of inch-thick polystyrene, available from DIY stores, are ideal but you will find a variety of collapsible ones, such as Lastolite, in most photo stores.

Studio-type flash equipment can be preferable to tungsten lights when photographing people, as the brief duration of the flash ensures a lack of subject movement. The mono-block system is ideal for such purposes, these have the flash generator, flash tubes and a modelling light built into a single small unit. One is connected by a synchronising lead to the camera and the others are fired simultaneously by a slave cell. You can use the camera's built-in metering system when using tungsten lighting but for flash lighting you will need to buy a special, separate flash meter.

For studio work you will also need to consider backgrounds. One of the most practical systems can be established by using nine-feet wide rolls of cartridge paper, available from photo stores in a wide range of colours. They can be suspended from wall brackets, sprung poles or tripod stands and draped onto the floor in a seamless curve. Alternatively, you can buy painted or textured fabric backdrops manufactured by companies such as Lastolite.

Technical Details
▼ Medium Format SLR Camera with a 200mm lens and Kodak Ektachrome 64.

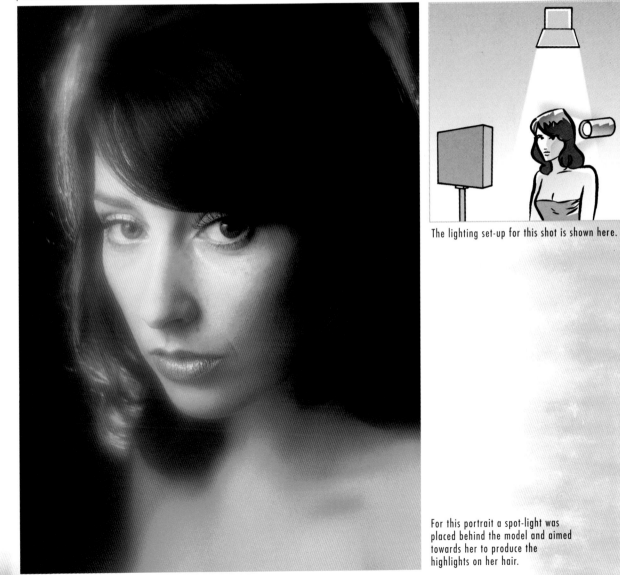

The lighting set-up for this shot is shown here.

For this portrait a spot-light was placed behind the model and aimed towards her to produce the highlights on her hair.

Apertures & Shutter Speeds

The aperture is the device which controls the brightness of the image falling upon the film and is indicated by f stop numbers f2 – f2.8 – f4 – f5.6 – f8 – f11 – f16 – f 22 – f32. Each step down, from f2.8 to f4, for example, reduces the amount of light reaching the film by 50% and each step up, from f8 to f5.6, for instance, doubles the brightness of the image.

The shutter speed settings control the length of times for which the image is allowed to play on the film and, in conjunction with the aperture, control the exposure and quality of the image.

Depth of Field

The choice of aperture also affects the depth of field (the distance behind and in front of the point of focus in which details appear acceptably sharp). At wide apertures, like f2.8, the depth of field is quite limited, making closer and more distant details appear distinctly out of focus.

The effect becomes more pronounced as the focal length of the lens increases and as the focusing distance decreases so with, say, a 200mm lens focused at two metres and an aperture of f2.8 the range of sharp focus will extend only a short distance in front and behind the subject.

The depth of field increases when a smaller aperture is used and when using a short focal length, or wide-angle lens. In this way a 24mm lens focused at, say, 50 metres at an aperture of f22, would provide a wide range of sharp focus extending from quite close to the camera to infinity. A camera with a depth of field preview button will allow you to judge the depth of field in the viewfinder.

The choice of shutter speed determines the degree of sharpness with which a moving subject will be recorded. With a fast-moving subject, like a person running, for instance, a shutter speed of 1/1000 sec or less will be needed to obtain a sharp image.

Technique

When a subject is travelling across the camera's view, panning the camera to keep pace with the movement will often make it possible to obtain a sharp image at slower speeds. This technique can be used to create the effect where the moving subject is sharp but the background has movement blur and can considerably heighten the effect of speed and movement.

Rule of Thumb

Shallow depth of field can be very useful especially in outdoor portraiture when it can be used to reduce background details to a soft homogeneous blur, making the subject stand out in sharp relief.

A small aperture was used here to ensure that both the foreground details and the distant figures would be recorded sharply.

Technical Details ➤
35mm SLR Camera with a 35–70mm zoom lens and Kodak Ektachrome 64.

A fast shutter speed was used for this picture to prevent the ladies' arms and their pestles from being blurred.

Technical Details

▼ 35mm SLR Camera with a 35–70mm zoom lens and Kodak Ektachrome 64.

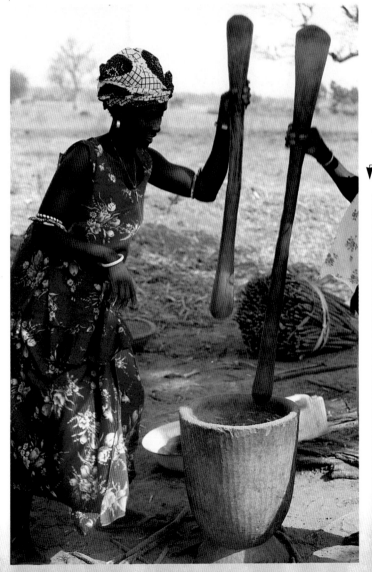

A wide aperture was used for this portrait to ensure the background would be out of focus.

Technical Details

▼ 35mm SLR Camera with a 75–300mm zoom lens and Kodak Ektachrome 64.

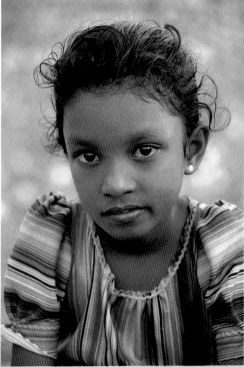

Understanding Exposure

Modern cameras with automatic exposure systems have made some aspects of achieving good quality images much easier, but no system is infallible and an understanding of how exposure meters work will help to ensure a higher success rate.

An **exposure meter**, whether it's a built-in TTL meter or a separate hand meter, works on the principle that the subject it is aimed at is a mid-tone, known as **18% grey**. In practice, of course, the subject is invariably a mixture of tones and colours but the assumption is still that, if mixed together, like so many pots of different-coloured paints, the resulting blend would still be the same 18% grey tone.

With most subjects the reading taken from the whole of the subject will produce a satisfactory exposure. But if there are aspects of a subject which are **abnormal**, when it contains large areas of **very light** or **dark** tones, for example, the reading needs to be **modified**.

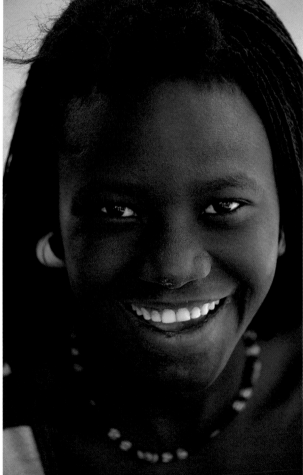

Technical Details
▼ 35mm SLR Camera with a 75–300mm zoom lens and Fuji Provia.

One stop less exposure than indicated was given to compensate for this subject's very dark skin.

Rule of Thumb

The most common situations in which the exposure taken from a normal average reading needs to be increased is when light sources are included in the frame, such as street scenes at night, when shooting into the light; when there are large areas of white or very light tones in the scene, such as a photograph of a child playing in the snow, for example; and when there is a large area of bright sky in the frame.

An exposure reading from a bride wearing a white dress for instance, would, if uncorrected, record it as grey on film. In the same way a reading taken from a very dark subject, like a portrait of an African tribesman, for instance, would result in his skin being too light.

The exposure needs to be decreased when the subject is essentially dark in tone or when there are large areas of shadow close to the camera. With abnormal subjects it is often possible to take a close up or spot reading from an area which is of normal, average tones.

Rule of Thumb

Many cameras allow you to take a spot reading from a small area of a scene as well as an average reading and this can be useful for calculating the exposure of subjects with an abnormal tonal range or of high contrast. Switching between the average and spot reading modes is also a good way of checking if you are concerned about a potential exposure error. If there is a difference of more than about half a stop, when using transparency film, you need to consider the scene more carefully to decide if a degree of exposure compensation is required.

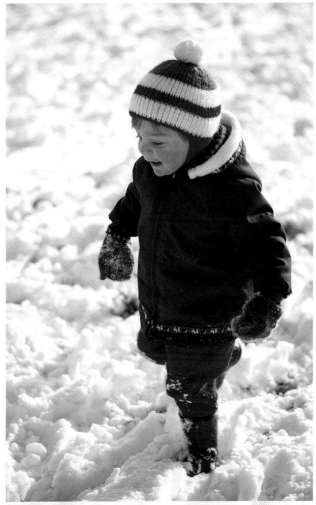

Technical Details
35mm SLR Camera with a 75–150mm zoom lens and Kodak Ektachrome 64.

One and a half stops extra exposure than the metre suggested was given for this picture to compensate for the bright snow background.

Understanding Exposure

With negative films there is a latitude one stop or more each way and small exposure errors will not be important, but with transparency film even a slight variation will make a significant difference to the image quality and, where possible, it's best to bracket exposures, giving a third or half a stop more and less than that indicated, even with normal subjects.

Technique

Clip testing is an effective way of overcoming this problem. For this technique you need to establish your exposure and shoot a complete roll at the same setting, assuming the lighting conditions remain the same. You need to allow two frames at the end of the roll, in the case of roll film, or shoot three frames at the beginning of a 35mm film, which you must ask the processing laboratory to cut off and process normally. The exposure can then be judged and the processing time of the remainder of the film adjusted to make the balance of the transparencies lighter or darker if necessary. Increasing the effective speed of the film, known as pushing, and making the transparency lighter, is more effective than reducing the film speed, known as pulling, to make the image darker. For this reason it is best to set your exposure slightly less than calculated if in any doubt.

Technique

Exposure compensation can also be used to alter the quality and effect of an image, especially with transparency film. When a lighter or darker image is required, this can be adjusted at the printing stage when shooting on negative film, but with transparency film it must be done at the time the film is exposed.

Technical Details
Medium Format SLR Camera with a 200mm lens and Kodak Ektachrome 64.

One stop more exposure than the meter indicated was given to create the high-key image and pastel hues in this portrait.

Rule of Thumb

Bracketing is not always the best solution when photographing people, as even a slight change in an expression or gesture can make one frame very much better than the next and in a bracket this might not be the best exposure.

One stop less exposure than the meter suggested was given for this nude to record full detail in the highlights and render the shadows as a black, featureless tone in order to create a more dramatic quality.

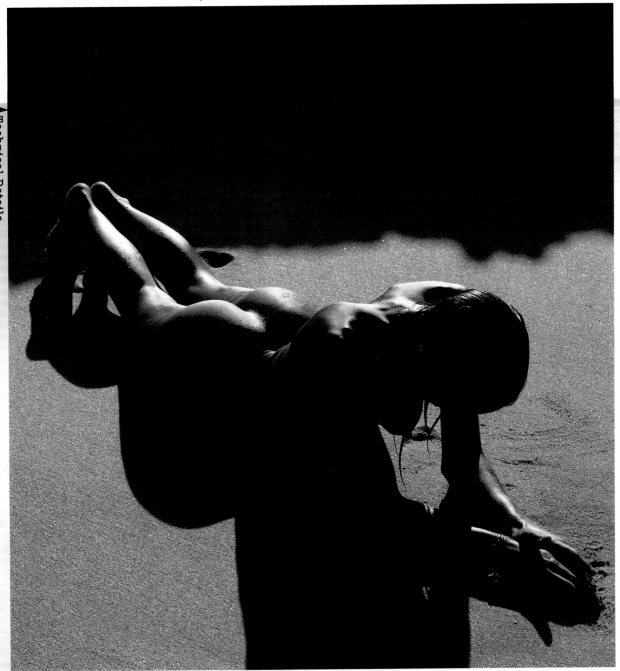

▲ Technical Details
Medium Format SLR Camera with an 80mm lens and Kodak Ektachrome 64.

Choosing Film

There is a huge variety of film types and speeds from which to choose and although, to a degree, it is dependent on personal taste, there are some basic considerations to be made. Unless you wish to achieve special effects through the use of film grain it is generally best to choose a slow, fine-grained film for photographing people if the subject and lighting conditions will permit.

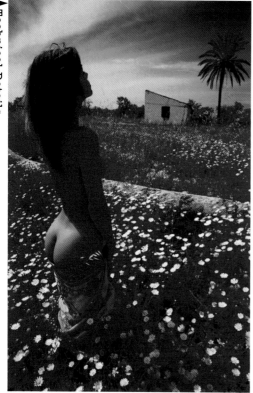

▲**Technical Details**
35mm SLR Camera with a 24mm lens and Kodak Infra Red Ektachrome.

Kodak's Infra Red Ektachrome was used for this nude image.

Technique

It's also important to appreciate that some films are more suited to portrait photography than others. Films such as Fuji Velvia or Kodak Ektachrome SW tend to create too much contrast and excessive warmth, producing rather harsh and unnatural skin tones. As a rule, slightly softer, more neutral films, such as Fuji Astia or Kodak Ektachrome 100 Professional, are a better choice.

The choice between colour negative film and transparency film depends partly upon the intended use of the photographs. For book and magazine reproduction, transparency film is universally preferred and transparencies are also demanded by most photo libraries. And, of course, transparency film is necessary for slide presentations.

But for personal use, and when colour prints are the main requirement, colour negative film can be a better choice, since it has greater exposure latitude and is capable of producing high quality prints at a lower cost.

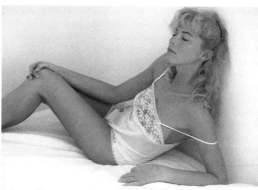

A fast colour transparency film was used for this image and push-processed in order to create a grainy quality.

Black-and-white Films

Although colour film is very widely used in people photography there are many situations which can be used to produce striking black-and-white images. Many established portrait and reportage photographers choose to work in black and white, especially for editorial work in magazines.

In addition to conventional black-and-white films like Ilford's FP4 and Kodak's Tri X there are also films such as Ilford's XP2 and Kodak's T400 CN which use colour negative technology and can be processed in the same way at one-hour photo labs to produce a monochrome print.

For special effects, fast films such as Kodak's 2475 recording film can produce a very pronounced, almost crystalline, grain structure which can look very effective with subjects such as nudes and documentary photography. Infra Red film, both black-and-white and colour, can also be used to produce images with a very unusual quality.

Agfa's Scala is a process-paid black-and-white transparency film with a particularly pleasing silvery, translucent quality. It too is ideal for those who don't wish to process their own films and it provides the opportunity to show the images in a slide projector as well as making it possible to produce reversal prints. It can be used to create interesting tinted monochrome effects using printing materials such as Ilfochrome.

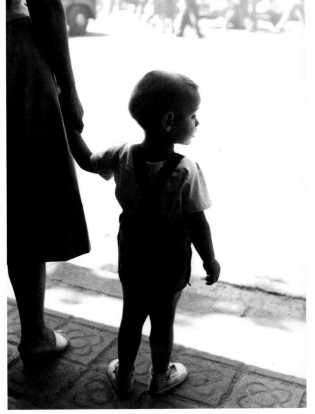

Black-and-white film was used for this picture of a child as I felt the image would be more striking in monochrome.

Technical Details
Medium Format TLR Camera with an 80mm lens and Ilford FP4.

Technical Details
35mm SLR Camera with a 35–70mm zoom lens and Agfachrome ISO 1000.

Using Filters

Even in the best conditions, filters are often necessary, especially when shooting on transparency film. It's important to appreciate that colour transparency film is manufactured to give correct colour balance only in conditions when the light source is of a specific colour temperature. Daylight colour film is balanced to give accurate colours at around 5,600 degrees Kelvin, but daylight can vary from only about 3,500 degrees K close to sundown to over 20,000 degrees K in open shade when there is a blue sky.

The effect of an imbalance between the colour temperature of the light source and that for which the film is balanced can be very noticeable in portrait photography because it can make skin tones look unattractive. The blue tint, for example, when shooting in open shade can be quite marked and in these situations a warm-up filter, such as an 81A or B, is needed. In late afternoon sunlight skin tones can become unpleasantly red and florid and for this a blue-tinted filter such as an 82A or B is needed.

Technical Details
▼ Medium Format SLR Camera with a 150mm lens an 82C filter and Kodak Ektachrome 64.

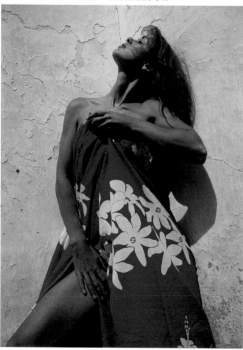

A polarising filter is perhaps less useful for photographing people than for subjects like landscape or architecture. But when the setting or background is an important element of a photograph, a polariser can be very useful for increasing the colour saturation of details such as foliage and for making the sky or sea a richer colour. It is equally effective when used with colour print film, whereas the qualities created by colour-balancing filters can easily be achieved when making colour prints from negatives. A polariser can also help to subdue excessively bright highlights when shooting into the light, like the sparkle on rippled water. Polarisers need between one and a half and two stops extra exposure, but this will automatically be allowed for when using TTL metering.

Neutral graduated filters are a very effective means of making the sky darker and revealing richer tones and colours. They can also reduce the contrast between a bright sky and a darker foreground giving improved tones and colours in both.

Technique

When shooting in black and white, a red or orange filter can be effective in minimising skin blemishes and a blue filter can be used to enhance the effect of skin texture when shooting character portraits, for example.

A blue-tinted filter was used for this shot to introduce a blue cast in order to create an unusual, atmospheric effect.

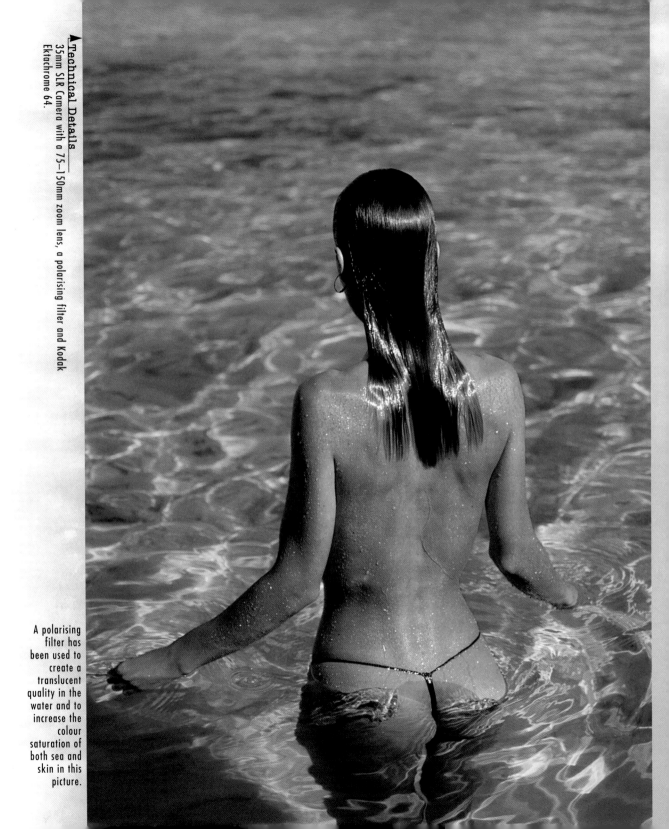

▲Technical Details
35mm SLR Camera with a 75–150mm zoom lens, a polarising filter and Kodak Ektachrome 64.

A polarising filter has been used to create a translucent quality in the water and to increase the colour saturation of both sea and skin in this picture.

Finishing & Presentation

Storing your Photographs

Card mounts are the most suitable way of storing and presenting colour transparencies. They can be printed with your name and address, together with caption information using labels. Added protection can be given by the use of individual clear plastic sleeves which slip over the mount.

Technique

When colour transparencies are to be used as part of a portfolio, a more stylish and polished presentation can be created by using large black cut-out mounts which hold up to 20 or more slides in individual black mounts, depending upon format. These can be slipped into a protective plastic sleeve with a frosted back for easy viewing.

Technique

Be quite ruthless about eliminating any rather similar or repetitive images. Even for personal use, the impact of your photographs will be greatly increased if only the very best of each situation is included and a conscious effort is made to vary the nature of the pictures.

Technique

For purely personal use, many photographers use flip-over albums as a means of showing their prints. This method is, at best, simply a convenient way of storing prints and does nothing to enhance their presentation. But it can be far more pleasing and effective to show a collection of images, say of a family holiday, as a series of prints mounted on the pages of an album, choosing one large enough to allow six or more photos to be seen together on a spread. Another way of presenting such images is on a large pin board or as a collage.

The impact of a photograph can be affected by the way it is framed and mounted, as shown here.

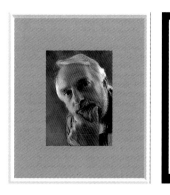
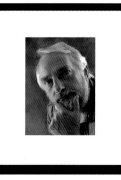
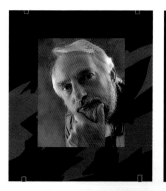
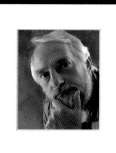

The effect of combining a number of well-chosen images is shown here.

Technique

Even the finest print will be improved by good **presentation** and **mounting** it flat onto a heavy-weight card is the first stage. Dry mounting ensures a perfectly **flat**, mounted print; this involves placing a sheet of **adhesive tissue** between the print and its mount and applying heat and **pressure,** ideally with a dry-mounting press but a domestic iron can also be used.

Technique

Strong images can be very effective for **display** in the home or office, such as portraits of family and friends, and a nicely-mounted group of prints in simple black or metallic **frames** can create a very effective focal point for the **decor** of a room.

Rule of Thumb

The simplest way of storing mounted transparencies is in viewpacks – large plastic sleeves with individual pockets which can hold up to 24 35mm slides, or 15 of 120 transparencies. These can be fitted with bars for suspension in a filing-cabinet drawer and quickly and easily lifted out for viewing. For slide projection, however, it is far safer to use plastic mounts, preferably with glass covers, to avoid the risk of popping and jamming inside the projector.

Rule of Thumb

For portfolio and exhibition prints, and those where archival permanency is required, it's best to simply hold the print in place onto the mounting board with acid-free tape across the corners and then complete the presentation by placing a bevel cut-out mount on top to frame it. You can cut these to size yourself using a craft knife, or there are special tools available, but they can also be bought ready-made in the most popular sizes from art stores.

Technique

Where photographs are taken for purely pictorial purposes, building up a body of work is one of the most stimulating and challenging projects for a photographer and the formation of a portfolio or collection of images with a central theme is an excellent way of doing this.

Technique

There are a number of ways of selling your work and finding a potential outlet for your work in print. Good people and life-style photographs are in constant demand by publishers of magazines and books dealing with travel, hobbies and outdoor pursuits, of which there are a large number, and there is a ready market for most subjects if the photographs are well-executed.

Bear in mind, however, that where photographs of an identifiable person are intended for publication it is often necessary to ask your subject to sign a model release form. This is simply a letter of agreement which states that they have granted you permission to offer the photographs for publication. Many photo-libraries will not accept images of people unless you have such an agreement.

Rule of Thumb

A good photo-library can reach infinitely more potential picture-buyers than is possible for an individual and can also make sales to the advertising industry, where the biggest reproduction fees are earned.

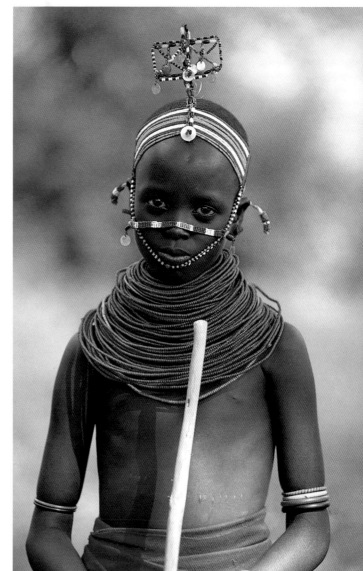

Technique

Spend some time researching the market in your local library, or at a friendly newsagents, and see just how the photographs are used in such publications and what type of image they seem to prefer. Make a note of some names, like the editor, features editor and picture editor.

There are some useful reference books available like the Freelance Writers' and Artists' Handbook and the Freelance Photographers' Market Handbook, but these are, at best, only a general guide to potential users and it is vital to study each publication before you consider making a submission.

Books and magazines represent only a small proportion of the publications which use photographs of people. Other potential outlets include travel brochures, calendars, greetings cards, packaging and advertising.

As a general rule, you will be expected to submit several hundred transparencies initially, and will probably be obliged to allow those selected to be retained for a minimum period of three years. Your selection should be ruthlessly edited, as only top-quality images will be considered, and you should make sure that no very similar photographs are sent, only the very best of each situation.

Although a good photo library can produce a substantial income in time from a good collection of photographs, it will take as much as a year before you can expect any returns and most libraries prefer photographers who make contributions on a fairly regular basis.

Technical Details
▼ 35mm SLR Camera with a 80–200mm zoom lens and Fuji Provia.

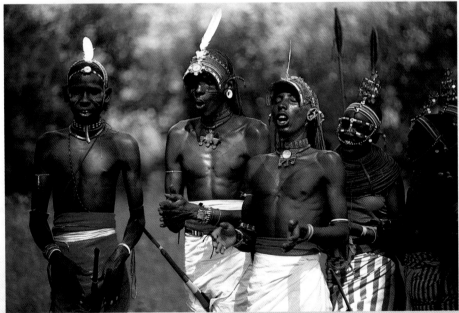

These two images of Samburu tribes people, from a series taken in an African village, have been reproduced many times to illustrate travel features and holiday brochures.

Glossary

Aperture Priority
An auto-exposure setting in which the user selects the aperture and the camera's exposure system sets the appropriate shutter speed.

APO lens
A highly-corrected lens which is designed to give optimum definition at wide apertures and is most often available in the better quality long-focus lenses.

Ariel Perspective
The tendency of distant objects to appear bluer and lighter than close details, enhancing the impression of depth and distance in an image.

Auto-Bracketing
A facility available on many cameras which allows three or more exposures to be taken automatically in quick succession, giving both more and less than the calculated exposure. Usually adjustable in increments of one third, half or one stop settings, and especially useful when shooting colour transparency film.

Bellows Unit
An adjustable device which allows the lens to be extended from the camera body to focus at very close distances.

Black Reflector
A panel with a matt black surface, used to prevent light being reflected back into shadow areas in order to create a dramatic effect.

Cable Release
A flexible device which attaches to the camera's shutter release mechanism and which allows the shutter to be fired without touching the camera.

Colour Cast
A variation in a colour photograph from the true colour of a subject, caused by the light source having a different colour temperature to that for which the film is balanced.

Colour Temperature
A means of expressing the specific colour quality of a light source in degrees Kelvin. Daylight colour film is balanced to give accurate colours at around 5,600 degrees K, but daylight can vary from only 3,500 degrees K close to sundown to over 20,000 degrees K in open shade when there is a blue sky.

Cross Processing
The technique of processing colour transparency film in colour negative chemistry, and vice versa, to obtain unusual effects.

Data Back
A camera attachment which allows information – like the time, and date – to be printed on the film alongside or within the images.

Dedicated Flash
A flash gun which connects to the camera's metering system and controls the power of the flash to produce a correct exposure. Will also work when the flash is bounced or diffused.

Depth of Field
The distance in front and behind the point at which a lens is focused which will be rendered acceptably sharp. It increases when the aperture is made smaller and extends about two thirds behind the point of focus and one third in front. The depth of field becomes smaller when the lens is focused at close distances. A scale indicating depth of field for each aperture is marked on most lens mounts and it can also be judged visually on SLR cameras which have a depth of field preview button.

DX Coding
A system whereby a 35mm camera reads the film speed from a bar code printed on the cassette and sets it automatically.

Evaluative Metering
An exposure meter setting in which brightness levels are measured from various segments of the image and the results used to compute an average. It's designed to reduce the risk of under, or over-exposing subjects with an abnormal tonal range.

Exposure Compensation
A setting which can be used to give less or more exposure when using the camera's auto-exposure system for subjects which have an abnormal tonal range. Usually adjustable in one third of a stop increments.

Exposure Latitude
The ability of a film to produce an acceptable image when an incorrect exposure is given. Negative films have a significantly greater exposure latitude than transparency films.